A Flower for Every Season

Japanese Paintings from the C. D. Carter Collection

by Robert Moes

The Brooklyn Museum

Published for the exhibition
A Flower for Every Season
Japanese Paintings from the C. D. Carter Collection

The Brooklyn Museum	April 30-August 10, 1975
University Art Museum, Berkeley	October 21-December 7, 1975
University of Michigan Museum of Art	March 21-April 25, 1976

Photography by Otto Nelson.
Designed and published by The Brooklyn Museum, Division of Publications and Marketing
Services, 188 Eastern Parkway, Brooklyn, New York 11238.
Printed in the USA by the Falcon Press, Philadelphia.

ISBN 0-87273-001-8
Library of Congress Catalog Card number 75-7577

FOREWORD

The art of Japan has frequently fascinated Western eyes. Its subtlety, intellectual complexity, and convincing beauty span thousands of miles with surprising ease. But we often see only what our Western tradition predisposes us to see.

When faced with a culture so different from our own, with no common cultural pool, we approach its art in limited terms. This is natural. But it sometimes leaves us with an understanding of the art that is without flesh and bones. Because of the apparent visual simplicity of much of Japanese art, we tend to approach it only as abstract form. While abstraction plays an important role and can help us understand what we see, we cannot stop there. The magnificent paintings in the present exhibition were produced by people—people with histories, names, identities, passions, conflicts, and needs. The artists lived in a particular place and a particular time. Dynasties rose and fell, Emperors clashed with Shoguns, monks introduced new religions, and trade missions opened new routes for artistic development. The artists' works here were produced against a backdrop of some nine hundred years of vigorous history. If we make the effort to understand the artists as people, then we will be rewarded with an understanding of their art. We can then begin to appreciate the total achievement of the Japanese people.

The material presented here is a rich canvas. Much of it is foreign to our sense of history—different and difficult. But, when we overcome the difficulties and examine the differences, we will come again to the convincing beauty of the paintings themselves. They are an enduring reminder that all art speaks with one voice, and, as often as it shows us our differences, it shows us our similarities.

An exhibition and the catalogue that helps broaden and perpetuate its impact call upon the best in museums. Like so many others, this project would not have been possible without the efforts and deep commitment of many people. *A Flower for Every Season* begins with the extraordinary collection of C. D. Carter. The growth of the collection matches his own growth in knowledge and understanding of Oriental art. We salute the contribution of Robert Moes, Curator of Oriental Art, who has organized this

exhibition and written this catalogue, both of which are informative, striking, and rich with surprises and rewards.

Our appreciation goes to the staff of the museums who pack, ship, install, design, guard, and maintain the exhibition, as well as all of those required to produce this handsome book. And, finally, we thank the New York State Council on the Arts for the generous support that made this exhibition and catalogue possible.

We know that, for all involved, what has been achieved is sufficient reward.

Michael Botwinick
Director
The Brooklyn Museum

ACKNOWLEDGMENTS

C. D. ("Nick") Carter is an unusually knowledgeable collector, a man who has taught himself to read enough Chinese and Japanese to translate the inscriptions on his paintings. Nick studies and enjoys his collections every day. He has always been extremely generous in sharing them with others, both by lending gladly to exhibitions and by donating major pieces to various museums. We are extremely grateful to Dolly and Nick Carter for their friendly hospitality and for their unhesitating willingness to make their superb collection of Japanese paintings available for this exhibition.

Mrs. Yoko Hollis deserves much credit for working out the very difficult poems inscribed on paintings number 8 and 24. Mr. Shinichi Doi was responsible for the splendid calligraphy of the Japanese title.

Robert Moes
Curator of Oriental Art
The Brooklyn Museum

For Kate Moes and Madge Perkins

NOTES ON THE TEXT

The format of this catalogue departs from the usual practice of introductory text followed by catalogue entries. Here the text and entries are integrated. Each painting is listed and described immediately following the discussion of its period and school. The paintings are arranged in roughly chronological order. The measurements given for the paintings do not include mountings; height precedes width.

In the middle of the twelfth century, near the end of the Fujiwara Period, two northern warrior clans, the Minamoto and the Taira, were asked to quell a revolt in Kyoto, the Imperial capital and cultural center of Japan. Sensing a power vacuum in Kyoto, both clans tried to assume control of the government, fighting for supremacy from 1156 to 1185. The events of this epic struggle inspired a repertoire of literature and paintings celebrating military valor, a subject that has remained popular in Japan.

The Minamoto clan defeated the Taira in 1185, and their leader, Yoritomo, became military dictator, or Shogun. As his capital, he chose the muddy fishing village of Kamakura in a wild northeastern province which the Minamoto had controlled before going south, and thus avoided the intrigues of the Imperial court in Kyoto. He established a military dictatorship over a feudal system of warriors and vassals. The Emperor remained the nominal ruler, but (as has been the case during most of Japan's history) he had no actual power. From 1185 until the Imperial Restoration of 1868, dynasties of warrior dictators ruled Japan.

Yoritomo's heirs lacked his brilliant, ruthless organizational ability, and control of the government was gradually usurped by some of the clan's own retainers, the Hōjō family. The Hōjō takeover was subtle; with typical Japanese circuity, they ruled through the office of Shogun's Regent.

In 897, after three centuries of cultural dependence on China, Japan had stopped sending official envoys and began to assimilate its earlier cultural borrowings. This policy of isolation continued into the Kamakura Period on official levels, but many Buddhist monks traveled to China for study. The Hōjō Regents revived the practice of sending merchant ships to the mainland until 1274, when the Mongol chieftain Kublai Khan, already the conqueror of China, sent an armada from Korea to destroy Japan. After some initial battles, the Mongol fleet was wrecked by a terrible storm, which the Japanese named Kamikaze ("Divine Wind") believing it to have been sent by the gods. Kublai Khan sent another fleet to Japan in 1281, but, again, a Divine Wind scuttled the Mongol armada.

The art of the Kamakura Period displays the same variety found throughout Japanese art. Although old traditions were seldom discarded, new ones were welcomed with great enthusiasm. The taste of the court nobility had dominated the art of the Fujiwara Period, but the delicacy, refinement, and poetic allusions characteristic of Fujiwara art did not suit the newly dominant military aristocracy, who joined the court nobility and Buddhist monks as art patrons. They preferred direct, realistic narrative paintings glorifying their own heroic deeds.

However, not long after the death of Yoritomo, his fears were realized. The toughness, directness, frugality, and martial spirit of the Minamoto warriors inevitably suffered when they tried to imitate the refinement of the courtiers. This is apparent in the art created after about the middle of the Kamakura Period. Traditions from the Fujiwara Period were revived, and styles became more delicate and less realistic.

Yamato-e ("Japanese paintings"), narrative handscrolls in bright color recounting deeds of great courtiers, monks, poets, and warriors, were one of the major achievements of Fujiwara and Kamakura art.

Buddhism, introduced to Japan through Korea in 552, challenged the native Shintō faith and became virtually a state religion by 710. Great monastery-temples thrived under Imperial patronage. Fujiwara Period nobles saw themselves destined for immediate rebirth in the Paradise of Amida Buddha, where the lakes and pavilions were thought to resemble court mansions and gardens in Kyoto. While rebirth in the Pure Land was theoretically open to everyone, noblemen seldom thought of the miserable peasants whose tax rice supported them. By the end of the Fujiwara Period, however, evangelist monks had begun preaching salvation through Amida to the common people throughout Japan. The popularization of Buddhism was the most important religious development of the Kamakura Period. Four Buddhist sects introduced in the twelfth and thirteenth centuries are still influential today.

Genkū (called Hōnen Shōnin, 1133–1212) founded Jōdo Shū ("Pure Land Sect"). Genkū emphasized chanting the *nembutsu*, the phrase "Namu Amida Butsu" ("Praise be to Amitabha Buddha"). He taught that simple faith in Amida plus repetition of

the *nembutsu* throughout one's life insured rebirth in the Pure Land.

Genkū's disciple Shinran (1173–1262) broke with his master and founded Jōdo Shinshū ("True Sect of the Pure Land"). Shinran taught that monks, theoretically celibate in other Buddhist sects, should be allowed to marry and have children. He made salvation easier to attain; according to his teachings, the recitation of a single *nembutsu* in good faith is sufficient to secure rebirth in Amida's Paradise. A pious, honest life is not essential; Amida's grace extends to everyone. Through such doctrines, Jōdo Shinshū became the most popular and prosperous Buddhist sect in Japan.

A nationalistic Japanese monk named Nichiren (1222–82) founded the Hokke Shū ("Lotus Sect"). He condemned the other Buddhist sects in outrageous statements and claimed that he alone could bring salvation to Japan. He had the good fortune to predict the Mongol invasions—not a difficult feat in light of the situation on the mainland—and took full credit for the Kamikaze, asserting that his prayers had brought the storms. He reinstated the Hokke-kyō ("Lotus Sutra"), with its emphasis on Sakyamuni Buddha, making it the central source and symbol of his sect. While condemning the *nembutsu*, he advocated an almost identical chant: "Namu Myōhō Renge-kyō" ("Homage to the Sutra of the Lotus of the Good Law").

At about the same time these popular sects were spreading among the masses, a very personal and enigmatic sect was imported from China. The introduction of Zen was the second major development in Kamakura Period Buddhism. This unorthodox sect, brought to Japan by Eisai in 1191, gained the patronage of the Hōjō Regents and became the favorite sect of the warrior class.

Eisai (1141–1215) studied Tendai Buddhism at Mount Hiei northeast of Kyoto and traveled to China for further study in 1168 and again in 1187. He introduced the Rinzai School (Chinese: Lin-chi) of Zen when he returned from his second trip. In 1223 Eisai's pupil Dōgen (1200–1253) returned from China with the doctrines of the Sōtō School (Chinese: Ts'ao-t'ung).

Zen (Chinese: Ch'an; Sanskrit: Dhyana, "meditation") is said to have been carried from India to China in the sixth century by the Indian sage Bodhidharma. This first patriarch of the Zen Sect is probably fictional; he is not mentioned in the Sanskrit Buddhist literature of India. Zen combines Indian Tantric mysticism with Chinese Confucian pragmatism and Chinese Taoist mysticism; many Zen doctrines seem more Chinese than Indian.

Among the important Zen doctrines that occur in Indian sacred texts such as the *Lankavatara Sutra* is the idea that everything in the universe is an illusion. One should therefore seek the Buddha within one's own heart (discover one's own Buddha-nature) rather than worship an illusory external Buddha. Confucian attitudes reflected in Zen include a direct, practical approach to everyday problems, a discipline of hard work, and a disdain for sacred texts and holy images. Taoism contributed the idea that one may better comprehend the universe and the self through study of the natural relationships among man, animals, plants, and the forces of nature.

Zen Buddhism enjoyed the official support of the Hōjō Regents and was favored by the military aristocracy. Zen emphasis on directness and self-discipline appealed to warriors. Since the Zen doctrine of non-duality recognized no basic distinction between life and death, Zen training helped them achieve the disregard for death necessary in expert swordsmanship. Zen pragmatism assisted the warlords in managing their affairs and in governing the country; they appointed Zen monks as their secular as well as spiritual advisors. These men were usually learned, hard-working, practical, and honest. They were often put in charge of trading ships to China; since many of them had studied there, they knew more about that country than anyone else in Japan.

Zen also gave the feudal lords access to some of the magnificent riches of China's Southern Sung culture, such as porcelains, paintings, and lacquerware. Among the goods brought back by Japanese trading expeditions were monochrome landscape paintings attributed to famous artists of the Southern Sung Court Academy, ink paintings by Ch'an monks, and brightly colored bird-and-flower paintings attributed to masters of both the Northern and the Southern Sung academies.

Zen Buddhism eventually influenced the development of Japanese art and Japanese taste even more than the rise of the military aristocracy. Ink monochrome painting was a product of the Zen milieu. The world's most profoundly spiritual gardens are those around the abbots' quarters of Zen monasteries and sub-

temples. Through the tea ceremony, Zen indirectly gave rise to a unique ceramic tradition that has provided inspiration for modern artist-potters all over the world.

1 JŪROKU RAKAN

Kamakura Period, 13th century

Set of sixteen hanging scrolls.
Ink and color on silk, each 28¼ x 16 inches.

A Rakan (Sanskrit: Arhat; Chinese: Lohan) is a disciple of the Buddha. Through vigorous self-discipline and observance of the Buddha Law, he has freed himself from the cycle of rebirth and from all craving, attaining the fourth and highest state of being in Hinayana Buddhism. He has rid himself of all defilements and obtained perfect knowledge. He is worthy of receiving respect and offerings, though he is generally portrayed as an ascetic.

The Jūroku Rakan ("Sixteen Arhats") are saintly disciples of the Buddha who have vowed to stay in this world and protect the Buddha Law, prolonging their lives on earth to transmit the Buddha Truth to succeeding generations. There are other traditional groupings of eighteen and even five hundred Rakan.

Zen Buddhism rejected the veneration of religious images that was central to the more orthodox Buddhist sects, just as it rejected their reliance on holy scriptures. Nevertheless, certain buildings in Zen monasteries do contain statues or icon paintings to provide spiritual assistance to members of the lay congregation who have not yet reached a high enough level of self-awareness to get along without them.

The Rakan theme was congenial with Zen doctrine. The disciples of the Buddha had achieved enlightenment through their own efforts rather than through the grace of interceding Bodhisattvas, as in the popular sects. The path to spiritual awakening pursued by a Zen monk involved this same sort of self-help approach.

Zen icons were painted not in the ink-wash style imported from China by Zen monks in the thirteenth to fifteenth centuries, but in the traditional Buddhist painting style with its ink outlines, bright mineral colors, and cut gold leaf. However, because so many Japanese monks were going to China for study during the Kamakura Period, even the orthodox Buddhist painting style reflected increasing contact with Chinese art. More conservative icon paintings continued to employ the traditional "iron-wire" line, a

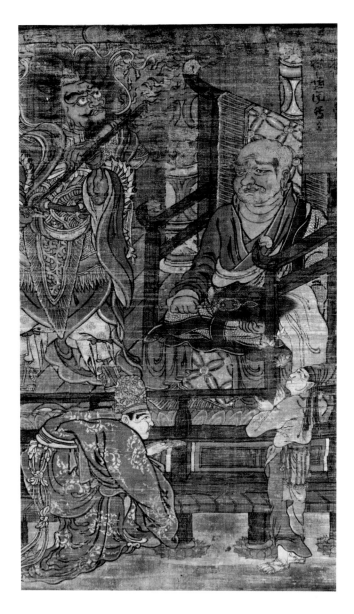

Pindolabharadraja

thin outline of almost unvarying width. The delicacy and richness of Fujiwara Period Buddhist painting, achieved through a profusion of minute decorative pattern, gave way to more powerful forms with less surface embellishment.

In more progressive Kamakura Period Buddhist paintings, the continuous "iron-wire" lines were replaced by a system of strongly modulated, shorter strokes adapted from Chinese calligraphy, a method that originated in the T'ang Dynasty and was characteristic of Chinese figure painting in the Sung Dynasty (960–1279). In the Southern Sung Dynasty (1127–1279), the modulated-stroke drawing style became standard for orthodox Buddhist painting. Its use in Japan was pioneered by painters of the Takuma School.

The Rakan paintings in this exhibition are rather conservative in their preference for continuous and only slightly modulated line. They are based on ultimate models from Northern Sung and T'ang Buddhist painting traditions rather than Southern Sung ones. But the familiar "nail head–rat tail" type of modulated stroke appears here and there, indicating that the artists of these scrolls were thoroughly acquainted with the newer tradition.

The inscription within the rectangular panel at the upper right of each painting gives the Rakan's number in the standard series as well as his name in Chinese characters used phonetically to approximate the sound of the Sanskrit.

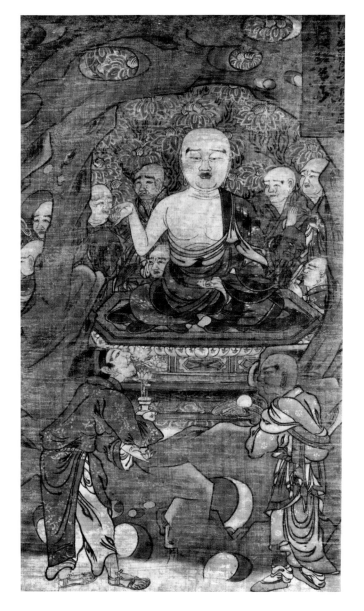

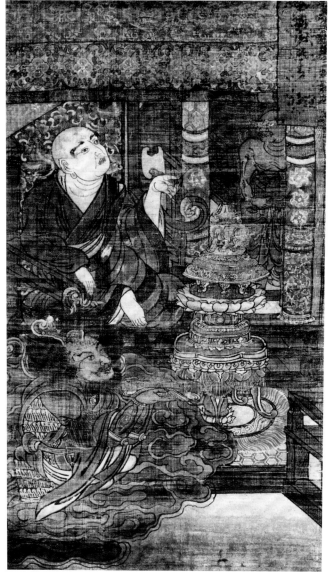

Kanakavatsa *Kanakabharadraja*

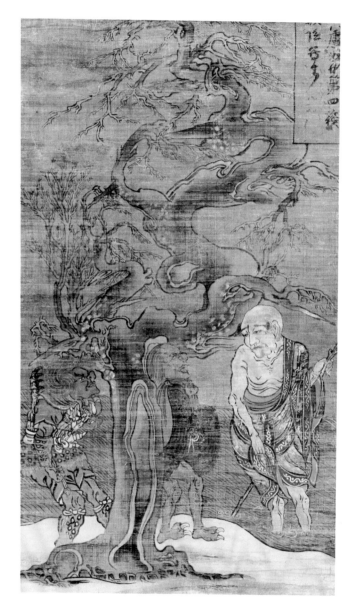

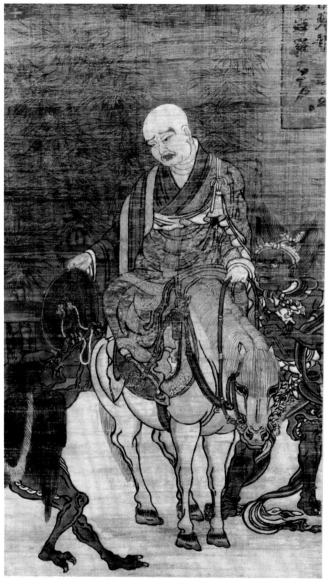

Subinda

Nakula

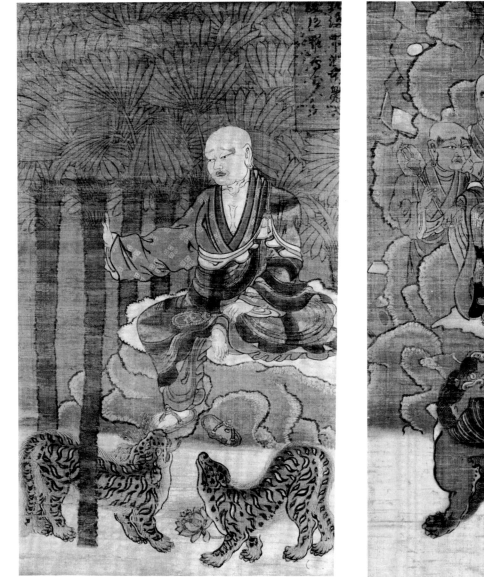

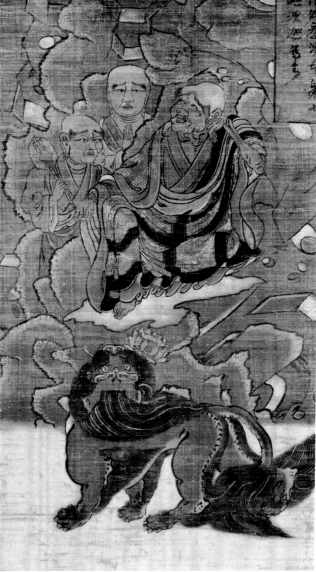

Bhadra

Kalika

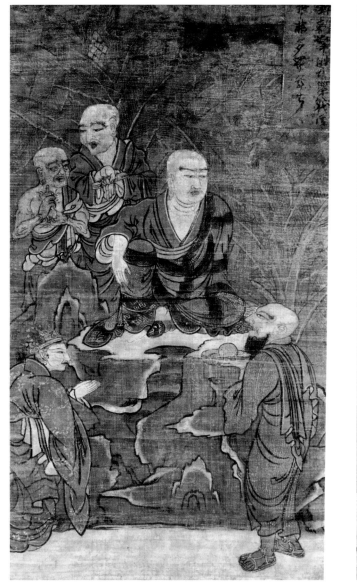

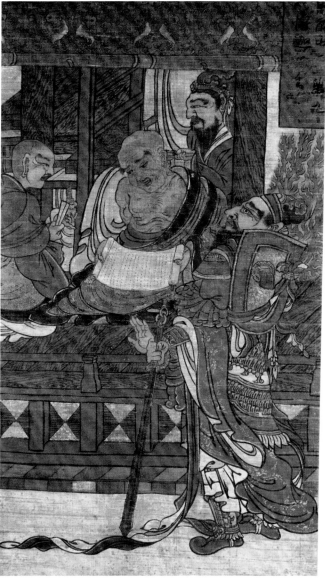

Vajraputra *Jivaka*

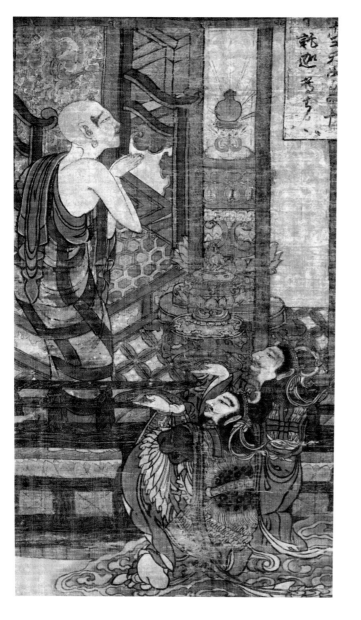

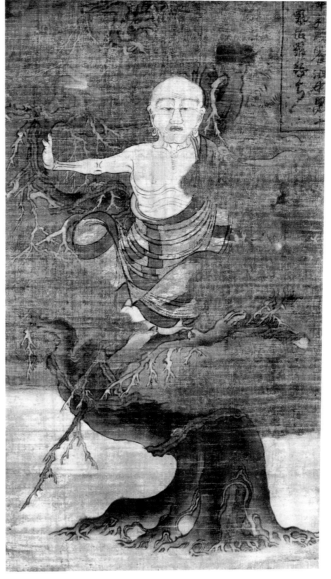

Panthaka　　　　　　　　*Rahula*　　　　　　　　15

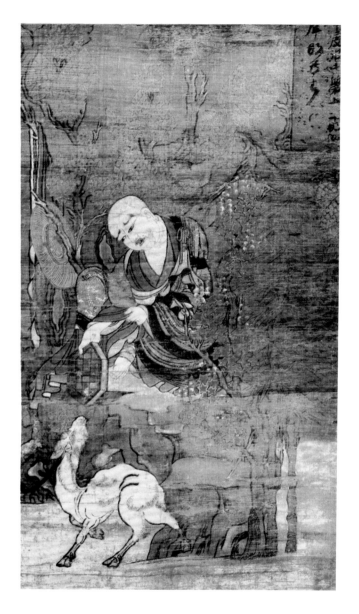

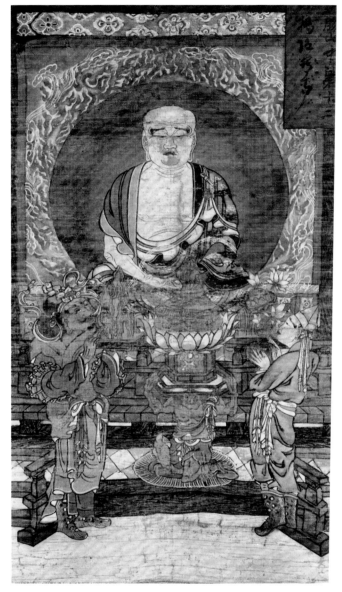

Nagasena

Angaja

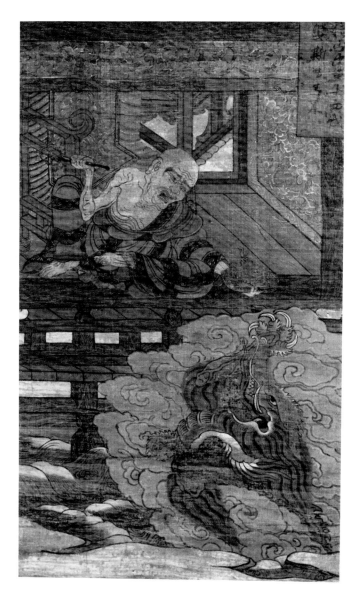

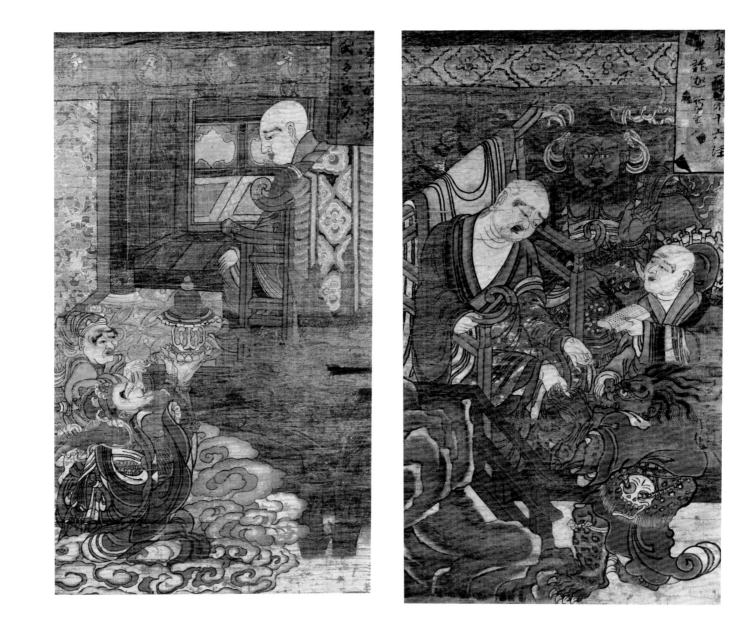

Ajita　　　　　　　　　　　　　　　　　　　　　　　*Cudapanthaka*

Go-Daigo, the ninety-sixth Emperor of Japan, reigned from 1318 until 1339. In the Kamakura Period, Go-Daigo's grandfather had quarreled with his brother over succession to the throne, and the military government had attempted to settle the dispute by decreeing that the succession would alternate between descendants of the two brothers. Go-Daigo was determined to keep the succession in his own line and to be more than a ceremonial functionary of the Hōjō Regents. The Shogunate tried to force his abdication, and he revolted in 1331. The revolt was backed by certain influential warriors dissatisfied with their status in the feudal hierarchy, and by armies of mercenary soldier-monks from several Kyoto monasteries.

Go-Daigo was captured and exiled, but escaped in 1333. The Hōjō Regent sent a warrior named Ashikaga Takauji from Kamakura to recapture him, but Takauji, hoping to be appointed Shogun himself, changed sides and backed Go-Daigo. Still another power-hungry warrior appeared, annihilated the Hōjō forces, and, with Go-Daigo's support, challenged Takauji for supremacy. Takauji crushed the challenger, took Go-Daigo prisoner, and established a prince from the rival Imperial line as Emperor. Go-Daigo escaped again and gathered his followers at Yoshino, where he established a court and claimed to be the legitimate Emperor. He died in 1339, but the two Imperial lines continued to reign simultaneously until the succession dispute was settled in 1392. The period of two rival Emperors, one in Kyoto (the northern court), the other at Yoshino (the southern court), is called the Nambokuchō Period ("Northern and Southern Courts") or the Yoshino Period.

Takauji was appointed Shogun by the northern court in 1338 and transferred the seat of military dictatorship to Kyoto. Settlement of the succession dispute in 1392 marked the end of the Nambokuchō Period and the beginning of the Muromachi Period, named after the section of Kyoto where the Ashikaga Shoguns had their headquarters. They held the title of Shogun until 1568 but were never able to establish effective control over the whole country. Local feudal lords were often virtually autonomous and sometimes more powerful than the Ashikaga themselves. Intermittent civil war continued throughout the Muromachi Period. Crop failures, famines, and epidemics made life almost unbearable for the

suffering peasants. The Ōnin Wars of 1467–77 began a period of more than one hundred years of constant civil war, the Sengoku Jidai, that lasted until 1573.

No major developments took place in architecture, sculpture, or ceramics in the Nambokuchō Period. Orthodox Buddhist painting and sculpture and Yamato-e settled into a state of aesthetic decline from which they never recovered.

The progressive and significant painting tradition of fourteenth-century Japan was *suiboku-ga* ("ink-wash painting"), which arose in the unorthodox milieu of Zen Buddhism. Ink paintings produced in Japan before the Nambokuchō Period consisted mainly of lines and strokes. In *suiboku-ga* many of the forms were defined with broad applications of ink wash subtly graduated from dark to light. With this technique an artist could achieve an illusion of volume and represent surface textures. Graded wash made it possible to suggest deep space filled with misty atmosphere, to create forms only partially defined, seemingly dissolving in mist or shadowy darkness. Paintings could become visual poems, evoking rather than delineating. The viewer could interpret a painting according to his own sensibility.

This approach to painting was highly compatible with Zen Buddhism. Zen scholar-monks used it to give visual embodiment to two seemingly contradictory teachings: the illusory quality of apparent reality and the deeper reality underlying appearances that could be grasped through an understanding of natural relationships. Of course, Zen monks were not the only Japanese artists to paint in ink wash, any more than they were the only Japanese artists to paint landscapes, animals, birds, and plants, but the technique appealed to their taste and the subjects took on added significance in their hands.

The great Chinese landscape painting tradition of the Five Dynasties (907–960) and Northern Sung (960–1127) periods influenced Japan very little because of her self-imposed isolation during the tenth and eleventh centuries. After the introduction of Zen Buddhism into Japan in the late twelfth century and the reopening of trade with China by the Hōjō Regent a few years later, Southern Sung (1127–1279) painting exerted a profound influence on Japan. Zen student monks and Hōjō or Ashikaga trading missions brought back Southern Sung Academy or Ch'an (Zen) paintings for the collections of the great Zen monasteries and the Shoguns. Zen painter-monks learned the styles of their Ch'an colleagues as well as those of Academy artists like Ma Yuan and Hsia Kuei.

A Japanese monochrome painting tradition based on the Ma-Hsia and Ch'an styles grew under the patronage of the Ashikaga Shoguns and feudal lords, becoming so dominant that the great literati painting tradition of China had no real impact on Japan until the late seventeenth century.

Dōshaku-ga ("Way-interpreting pictures") are ink-wash paintings that deal specifically with Zen themes. They present enigmatic characters from Zen history and legend. Such paintings have a partly didactic purpose: the characters' seemingly peculiar behavior provides clues to Zen enlightenment. Landscape elements are present only to provide the setting.

Landscape had been the dominant theme in Chinese painting from the tenth century. In keeping with the pantheistic cosmology of Sung Dynasty Neo-Confucianism, a landscape painting represented more than mere scenery; it represented Nature, everything in the universe, and, by extension, god. Although post-Sung literati painters were more concerned with expressing their own personalities, the continuity of Chinese tradition assured that no landscape painting was ever completely secular. The natural relationships implicit in the landscape theme gave it special meaning for Ch'an painter-monks.

Landscape as an independent subject came to Japan in the company of Zen. The earliest great landscape painter of Japan was a Zen painter-monk named Shūbun Ekkei (ca. 1390–ca. 1464). In spite of his fame in later periods and the large number of paintings attributed to him, only a few facts about Shūbun's life are known. He was in charge of accounts for general affairs at Shōkokuji, the Kyoto Zen temple where the Ashikaga Shoguns are buried. He went to Korea in 1423 with a group sent by Yoshimochi, the fourth Ashikaga Shogun, to obtain a complete set of Buddhist scriptures. He returned to Japan in 1424. The *Onryoken Nichiroku*, a journal of events for the years 1435 to 1493 kept by Zen scribes at the request of the military government, mentions Shūbun twice. In 1430 he painted the statue of Daruma at Yamato Darumaji. In 1440 he

supervised the carving of the main image of Amida and a pair of Guardian Kings at Ungoji.

Shūbun seems to have been appointed Painter-in-Attendance to the Shogun and made head of a newly established painting academy (e-dokoro) created in imitation of those of the Sung Emperors and the Japanese Imperial court.

Shūbun's painting style was based ultimately on landscapes by the famous Southern Sung Academy artist Hsia Kuei. By the fourteenth century, when this style was introduced to Japan, it was already obsolete in China. The Southern Sung Dynasty had fallen to the Mongols in 1279. Literati painting had become the dominant Chinese painting tradition of the Yuan Dynasty (1260–1368) and later. China's Confucian-trained scholar-bureaucrat-artists, who were also the art critics of their day, liked neither Southern Sung Academy painting nor Ch'an painting. However, conservative artisan painters working in Hangchou and Ning-po continued using the Southern Sung Academy style throughout the Yuan Dynasty. Early in the Ming Dynasty (1368–1644), the style was picked up by professional painters of the Chê School. Although progressive Ming painting was in literati style, the Chê School enjoyed some prestige through patronage from the Ming court. By the fourteenth and fifteenth centuries, most of the paintings brought back to Japan by Zen monks and trading expeditions were Yuan and early Ming artisan-work renditions of Southern Sung Academy and Ch'an styles, often with pious attributions to great Sung artists. Shūbun's style incorporated the Hsia Kuei style as transmitted through Yuan artisan paintings and early Ming Chê School renditions. The emphatic tall central promontory he often used was not a Southern Sung motif; it came from the Northern Sung landscape tradition by way of Chê School and Korean reinterpretations. In spite of the Chinese and Korean influences, however, Shūbun's paintings are clearly Japanese. Their spatial transitions are handled less confidently than in China. The effect of misty atmosphere on landscape elements is not as well understood. If judged by Chinese standards, Shūbun's paintings are clumsy and provincial. If judged on their own merits, however, their shortcomings in the treatment of space and atmosphere are outweighed by their superb formal design and their consummate handling of flat patterns on the picture plane.

The Muromachi Period's greatest artist was Sesshū Tōyō (1420–1506). Born to the Oda family at Akihama, Bitchū Province (modern Okayama Prefecture), in 1420, he became a Zen novice at the Hōfukuji monastery in 1431, where he was given the priest name Tōyō. From 1440 until 1456, when he left to avoid the civil war, he lived at Shōkokuji in Kyoto where he may have studied painting under Shūbun. In the inscription on Splashed-Ink Landscape, painted in 1495, Sesshū pays homage to Shūbun. By 1464 he was living at Unkokuji in Yamaguchi, Suō Province (modern Yamaguchi Prefecture), and was already famous as a painter. In 1466 he took the art name Sesshū.

Sesshū chose to live in Yamaguchi because it was near the southwestern tip of Honshū, close to Korea and China. The feudal lords of the Ōuchi clan who ruled the area were interested in bringing the arts to Yamaguchi and in trade with China. Hoping to visit China, Sesshū won the patronage of the Ōuchi Daimyo (a feudal lord). In 1468 he left for China with a merchant fleet dispatched by the military government. He went to the old Southern Sung capital of Hangchou, which had maintained its position as a cultural and religious center through the Yuan Dynasty and into the Ming. After making the journey from Hangchou to Peking, the Ming capital, Sesshū returned to Japan in 1469.

Since Kyoto was still being ravaged by the civil war, Sesshū settled near the town of Ōita in Bungo Province (modern Ōita Prefecture), Kyūshū, where he painted for the Ōtomo Daimyo. From 1481 to 1484 he took a leisurely journey through Japan. In 1486 he returned to Yamaguchi and built a painting studio under the patronage of the Ōuchi clan again. He died in 1506.

Sesshū's masterwork, the Long Landscape Scroll of 1486 in the Mori collection, shows his version of the Hsia Kuei style as handed down by Yuan Dynasty artisan-painters to the Chê School in the early Ming Dynasty. Sesshū mentions the Chê School artist Li Tsai in the inscription on his Splashed-Ink Landscape of 1495 as one of the painters whose work he had studied in China. Sesshū has left us a direct copy he made of an album-leaf by Hsia Kuei, and another by Li T'ang, founder of the Southern Sung Academy landscape tradition.

Sesshū turned the Southern Sung–derived landscape painting tradition into a truly Japanese style. He created a boldly exagger-

ated, intense, expressive, angular black line that became the dominant element of his art. It is unmistakably Japanese and has been perpetuated until modern times by the Kanō School and others.

In the second half of the fifteenth century, the monochrome painting tradition brought from China by Zen monks in the fourteenth and fifteenth centuries began to be secularized. Professional painters, often members of the warrior class, gradually took over. Zen painter-monks became largely a thing of the past.

The hundred years of civil war at the end of the Muromachi Period had a significant cultural side effect: with Kyoto nearly destroyed, many artists, craftsmen, and learned monks fled to other parts of the country. The high culture that had previously been largely confined to Kyoto and Kamakura was dispersed throughout Japan. For the first time, warlords in the provinces could rival the cultural attainments of the Imperial and Shogunal courts.

2 LANDSCAPE: THE EIGHT VIEWS OF HSIAO-HSIANG

Muromachi Period, 16th century

Pair of six-fold screens.
Ink on paper, each screen 65¾ x 146½ inches.

The style of this superb pair of anonymous late Muromachi screens is decidedly eclectic, but the foreground buildings and trees derive directly from the work of Sesshū; his heavy, expressive black line is readily apparent. These screens form an important link between Sesshū's obscure handful of pupils and the Unkoku School of the Momoyama Period (1568–1615), a school founded by Unkoku Tōgan (1546–1618) that revived the Sesshū style. The general appearance of these screens is very close to Unkoku School works.

After about 1450, Japanese ink-wash painting was taken over by professional artists. The present screens were probably produced by a professional painter about the middle of the sixteenth century. The rounded hills in the screens relate to the style associated with Sōami (died 1525) rather than to the sharply angular cliffs preferred by Sesshū. Sōami was a professional painter, connoisseur, and garden designer who served the Ashikaga Shogun.

Sōami preferred smooth, parallel, linear texture strokes that followed the contours of his hills. The pointillist dots of wash used as texture strokes on the rounded hills in these screens were borrowed from a Northern Sung landscape painter named Mi Fu (1051–1107), who built up the forms of his hills with repeated, small, horizontal dabs of wash. This mannerism entered the Chinese landscape painting vocabulary and was used by countless later artists; the little dabs came to be called "Mi dots." Their occasional appearance in Muromachi paintings is an exception to the rule that *suiboku* landscape derives from the Southern Sung Academy and Ch'an monasteries. Mi Fu was one of the great early exponents of *wenjenhua*, the painting of literary men. With a few exceptions, literati painting had almost no impact on Japanese art until Chinese painters, fleeing the collapse of the Ming Dynasty, brought it to the Chinese colony at Nagasaki and trained a few Japanese pupils.

The lakeside landscape in this pair of screens incorporates the "Eight Views of Hsiao-Hsiang" (Japanese: Shōshō Hakkei), a con-

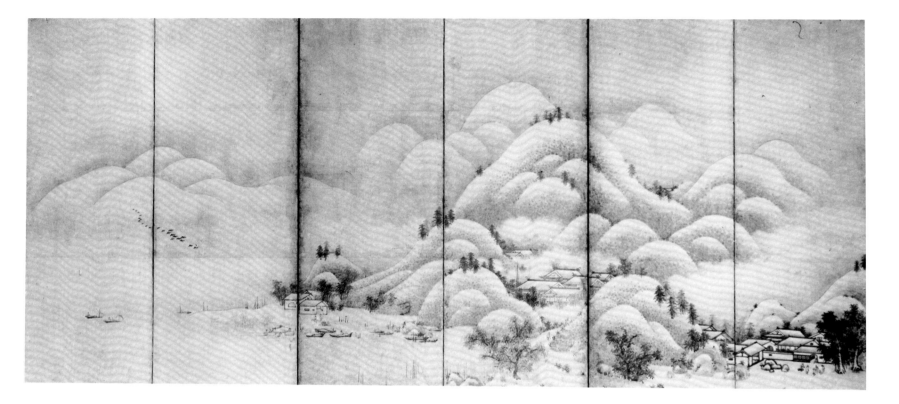

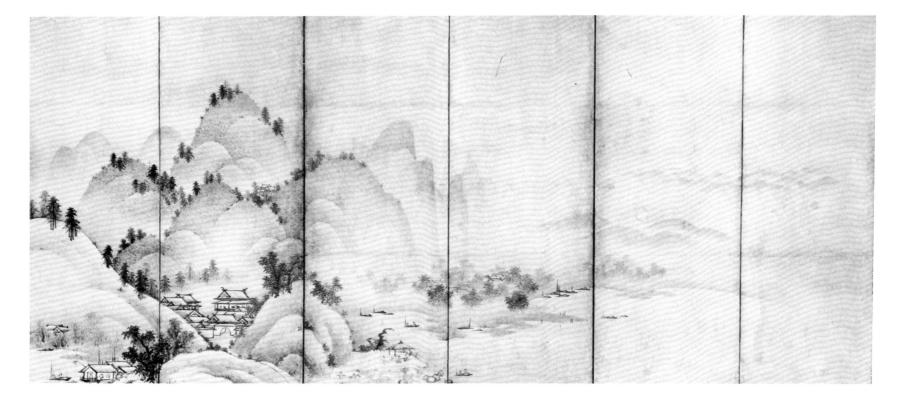

24

ventional set of scenic views that came to Japan from Southern Sung China. Each of the views has a specific title meant to inspire an idyllic landscape composition. Hsiao and Hsiang are two rivers in Hunan Province that flow together just before they empty into Lake Tung-t'ing. The scenery in this region is celebrated for its great beauty. Paintings of the "Eight Views of Hsiao-Hsiang" were produced in China from the eleventh century; the theme flowered in the Southern Sung period. The low hills, lakes, rivers, and mist-filled atmosphere of the Hsiao-Hsiang region were similar to those around Hangchou with its West Lake. This type of terrain, so typical of Central and South China, influenced the development of Southern Sung landscape painting, with its preference for relatively low, gentle, misty lakeside scenery, as compared to the towering crags of Northern Sung landscapes, which in turn reflected the topography in parts of North China.

With the transfer of the Sung capital to the south in 1127, the Chinese attitude toward man's place in nature gradually changed. Man's almost antlike stature against the awesome grandeur of nature in Northern Sung paintings gave way to a more anthropocentric view of man comfortably ensconced in a landscape that was not only hospitable but poetically lovely. This Southern Sung attitude toward nature happened to be current at the time and place where the Japanese monks and trading missions were visiting. The Japanese readily accepted this point of view; it reinforced their traditional reverence for their natural surroundings, one of the factors which had molded, and was molded by, the native Shintō religion.

The "Eight Views of Hsiao-Hsiang," which do not occur in any fixed order, are: "Clearing After a Storm in the Mountain Village" (panels 1, 2, and 3 of the right screen, reading from right to left as in a handscroll), "Evening Bell from the Distant Temple" (panel 5 of the left screen), "Returning Sails on the Distant Bay" (panel 6 of the right screen), "Night Rain at Hsiao-Hsiang" (panel 3 of the left screen), "Evening Glow on the Fishing Village" (panel 6 of the left screen), "Autumn Moon over Lake Tung-t'ing" (panel 2 of the left screen), "Wild Geese Coming Down on a Sandbar" (panel 5 of the right screen), and "Evening Snow on the River" (panel 4 of the right screen). The compositional scheme used in these screens, with hills, trees, and buildings piled up at both ends framing a

relatively empty area of open lake and mist in the center, is typical of landscape screens during and after the Muromachi Period.

The Momoyama Period, which lasted only forty-seven years, was extremely significant in the political and cultural history of Japan. During most of the Muromachi Period, Japan had been divided into a number of warring fiefs and the Ashikaga Shoguns had ruled in name only. During the Momoyama Period, control was assumed by the "Three Great Unifiers of Japan": Oda Nobunaga (1534–82), Toyotomi Hideyoshi (1536–98), and Tokugawa Ieyasu (1542–1616).

Oda Nobunaga was a samurai (a member of the hereditary military aristocracy) and the Daimyo, a feudal lord, of the Nagoya region. He decided to take over all of Japan, captured Kyoto in 1568, and installed a member of the Ashikaga family as puppet Shogun, only to depose him in 1573. Using principles of European defensive architecture which had been introduced by the Portuguese and Spanish, Nobunaga built the first Japanese castle in 1576 at Azuchi near Lake Biwa just north of Kyoto. Azuchi Castle was destroyed in 1582 when Nobunaga was murdered by one of his own vassals.

During the chaos of the late sixteenth century, commoners or low-ranking samurai were sometimes able to assume positions of great power for the first time in Japanese history. Toyotomi Hideyoshi, the second of the Momoyama Period's "Three Great Unifiers of Japan," was a farmer's son who served as a foot soldier under Nobunaga and rose by sheer cunning to become his top general. Hideyoshi avenged Nobunaga's death by destroying his slayer and, predictably, took control of Japan himself. By 1590 he had reunified the country.

With no more worlds to conquer at home, Hideyoshi sent his armies on an ill-advised adventure: the attempted conquest of China by way of Korea. The first invasion, in 1592, was contained by Korean troops. A second force sent in 1597 made little progress and, when the armies learned of Hideyoshi's death in 1598, they immediately abandoned the invasion attempt and returned to Japan, leaving the Korean peninsula brutally ravaged.

Hideyoshi built a number of castles and palaces, including Osaka Castle, the greatest fortress of its day. It was completed in 1586 but destroyed by Ieyasu in 1615. The gigantic stone walls of some of its inner moats may still be seen. In 1594, he built another castle at Fushimi, a few miles south of Kyoto. This castle, too, was later destroyed and peach trees were planted on the hill where it had stood. The place thus came to be called "Momoyama" ("Peach Hill"). Before the middle of the sixteenth century, Japanese forts had been simple hilltop camps protected by wooden stockades. But in 1542 firearms were introduced into Japan by three Portuguese adventurers sailing from South China aboard a Chinese pirate junk who were shipwrecked off Tanegashima, a tiny island near the coast of Kyūshū. Their matchlock muskets fascinated Japanese warlords, who saw their potential advantages. Japanese craftsmen were soon manufacturing copies of Portuguese muskets, and defensive stone forts became necessary.

In 1546 Jesuit missionaries, already active in India and China, arrived in Japan. Saint Francis-Xavier himself visited Japan from 1549 until 1551. Portuguese and Spanish trading galleons soon began stopping in Japan. The first Dutch ship arrived in 1609, the first English one in 1613.

Both Nobunaga and Hideyoshi tolerated the missionaries and merchants at first. They were anxious to obtain European products, prized novelties in Momoyama Period Japan. Because Europeans had arrived in Japan from the south, the foreign-style objects were called *namban* ("southern barbarian"). They inevitably influenced the design and ornamentation of many Japanese products. Paintings of Europeans in Japanese style and technique gleefully caricatured the oversized noses and baggy pantaloons of the foreigners. Many Jesuit missions trained Japanese converts to produce religious images with the techniques of oil painting. A few Japanese painters outside the mission ateliers experimented with oils or tried combining them with Japanese media, and some artists even attempted to imitate the *chiaroscuro* of European paintings and engravings. Most of the European trade goods and Japanese objects showing European influence or having European subject matter were destroyed in later persecutions of Christian converts.

The Jesuits had considerable success, especially on the island of Kyūshū, where they converted tens of thousands of peasants, and even a few samurai and one or two feudal lords. Hideyoshi began to view the Europeans as a threat and issued an edict in 1587 banishing all missionaries from Japan. Little was done to enforce it until 1596, when a ship's pilot, hoping to secure a trade advantage

for Spain, hinted that the Portuguese planned to make Japan a colony. Understandably alarmed, Hideyoshi began to enforce the ban; nine Europeans were crucified in 1597.

One of Hideyoshi's leading generals, Tokugawa Ieyasu, emerged victorious in the power struggle following Hideyoshi's death. Ieyasu defeated his rivals at the battle of Sekigahara in 1600 and had the Emperor award him the title of Shogun in 1603. He killed Hideyoshi's son and his supporters at Osaka Castle in 1615 to insure that there would be no challenges to his rule.

At first Ieyasu tolerated European missionaries and merchants and permitted the Dutch, English, Portuguese, and Spanish to trade in Japan. But in 1612 he isolated Japan as a precaution against possible threats to the survival of his regime. He began to enforce the anti-Christian edicts and to deport missionaries. Christianity was banned in 1614.

Persecution of Christians became severe under Ieyasu's successor, Tokugawa Hidetada. Japanese converts were forced to tread on copper panels bearing images of Christ or the Virgin to prove they had renounced Christianity; those who refused were executed. In the Shimabara Rebellion of 1637–38, thirty-five thousand Christian peasants rebelled against the government after four years of crop failures. Led by some Christian *rōnin* (masterless samurai), they prepared to withstand siege in Shimabara Castle. The government ordered Dutch ships to bombard the castle, and the rebels were killed to the last man. During the twenty-five years following Ieyasu's ban on Christianity, two hundred and eighty thousand of the seven hundred thousand Japanese converts were executed and the remainder renounced their faith.

Toyotomi Hideyoshi's parvenu taste provided an impetus for a magnificent outpouring of big, brightly colored paintings that are the major glory of Momoyama art. The audience halls and formal rooms of warlords' palaces became the setting for extensive series of wall paintings, sliding-door paintings, and screen paintings. Only a few have survived; most perished in the civil wars almost as soon as they were set in place.

Screens and sliding-door paintings in color existed before the Momoyama Period. They are mentioned in the literature of the Fujiwara Period and illustrated in the twelfth-century *Genji Monogatari E-maki*. But the bold sweep of Momoyama compositions and the close-up treatment of Momoyama subjects were distinctly different from earlier paintings. Gold decoration had been used sparingly before, but in the Momoyama Period entire backgrounds were done in gold leaf.

Kanō Eitoku (1543–90) was the major practitioner of the bold Momoyama painting style, though his rivals outside the Kanō School also made brilliant contributions to the new style. Eitoku perfected a mode of painting brought to the verge of its Momoyama magnificence by his grandfather and teacher, Kanō Motonobu (1476–1559) in the late Muromachi Period.

Ming Dynasty academic bird-and-flower paintings by artists such as Lu Chi influenced both the style and the subject matter of Motonobu and Eitoku. Kanō School brushwork, with its heavy, jagged, black line, shows the influence of Sesshū and his Ming Chê School sources. The Chinese gentlemen depicted in Kanō paintings evolved from figure paintings of the Southern Sung, Yuan, and Ming dynasties. Chinese styles are by no means the only influences apparent in Momoyama painting. Strong color dominated by heavy mineral green and earth brown was derived from Yamato-e, which was transmitted through the Tosa School in the Muromachi Period. The use of elements from Yamato-e and Tosa style by artists of the Kanō School became common after Kanō Motonobu married the daughter of Tosa Mitsunobu, although Kanō remained the official "Chinese style" school, serving the military aristocracy, while Tosa continued to be the "Japanese style" school, serving the Imperial court.

Eitoku enjoyed the patronage of the most important men in Japan. Called to Azuchi Castle by Oda Nobunaga in 1576, he supervised the vast series of sliding-door paintings in the residential mansions below the castle towers, all of which perished with the destruction of the castle. After Nobunaga's death, Eitoku was appointed to serve Hideyoshi. He directed the enormous cycles of wall and door paintings for Osaka Castle and Jūrakudai Palace but died before work began on Fushimi Castle. No painting from either Osaka Castle or Jūrakudai is known to have survived.

Among the finest extant works of Kanō Eitoku are the twenty-four *fusuma* (interior sliding doors) at the Jūkō-in sub-temple of Daitokuji, Kyoto, where the grave of Hideyoshi's tea master,

Sen-no-Rikyū, is located. Their concentration on a few large-scale forms near the picture plane, with almost no middle distance or deep space, is characteristic of the new style. Although Eitoku painted the Jūkō-in panels in 1566, when he was only twenty-four years old, the power of their sweeping compositions, the strength of their brushwork, and the keen understanding of figures, animals, and plants reveal Eitoku's genius already in full flower. The panels are painted in ink wash with delicate gold wash to suggest mist. Monochrome *fusuma* like this series were preferred for Zen temples.

Bright mineral colors and gold leaf were generally used for wall paintings, *fusuma*, and folding screens in the audience halls and formal rooms of palaces and mansions. Momoyama painting is an art of frank ostentation. The bright color and gold leaf background picked up the limited light in a wide, low room to create a rich, shimmering display.

Hasegawa Tōhaku (1539–1610) painted a series of *Maple and Cherry Tree fusuma* at the Chishaku-in in Kyoto in 1593. They cannot be surpassed for richness, boldness, and harmony. Tōhaku was the son of a dyer from the town of Nanao in Noto Province; his early name was Nobuharu. He may have been trained by Kanō Shōei, Eitoku's father, or by Eitoku himself, though evidence is lacking. Tōhaku was a friend of Hideyoshi's tea master, Sen-no-Rikyū. He resented the Kanō monopoly on important patronage and joined Rikyū in criticizing the Kanō School.

Tōhaku was inevitably influenced by Eitoku's style but avoided slavish imitation of it. Hoping to create a lineage of his own, he claimed artistic descent from Sesshū. He may in fact have studied with Sesshū's pupil Tōshun as the character "Tō" in their names is the same. A teacher frequently awarded one character of his art name to a pupil. On the other hand, Tōhaku could have simply appropriated the "Tō" out of reverence for Sesshū; the same "Tō" is in Sesshū's priest name, Tōyō. The signatures on Tōhaku's paintings sometimes say "fifth generation from Sesshū." In the early 1590's Unkoku Tōgan, who styled himself "third generation from Sesshū," brought suit against Tōhaku over the right to claim such lineage and won a restraining order against him.

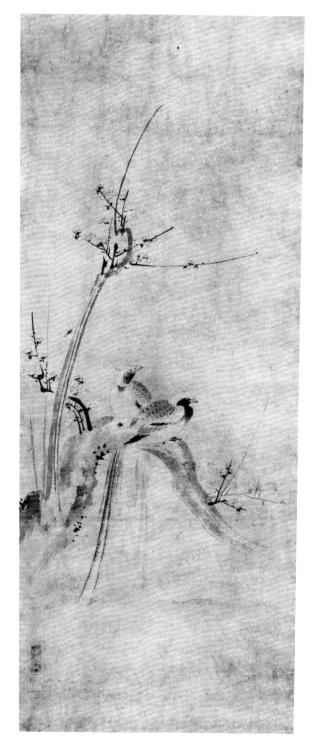

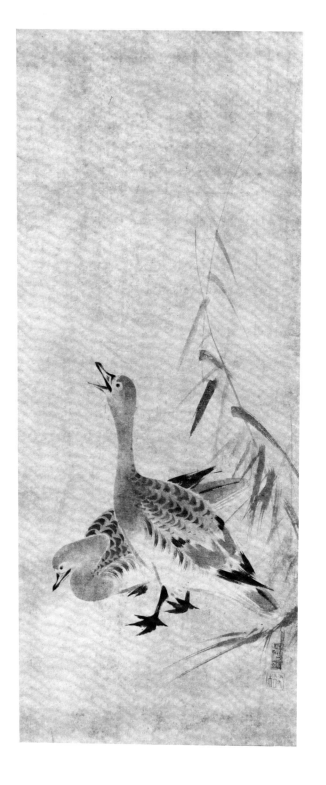

3 GEESE AND REEDS;
LONG-TAILED BIRDS ON FLOWERING PLUM

Kaihō Yūshō (1533–1615)

Two hanging scrolls.
Ink on paper, 44¼ x 18 inches; 44¼ x 17½ inches.

Upper seal (vertical rectangular, intaglio): Kaihō. Lower seal (square, relief): Yūshō.

Like Eitoku and Tōhaku, Kaihō Yūshō created powerful paintings in both color-and-gold and monochrome, but with a freer style and more fluid line. In this he sought to emulate Liang K'ai, an artist who left the Southern Sung Academy to paint in a Ch'an monastery.

Yūshō was a samurai, but entered the Tōfukuji Zen monastery in Kyoto while a small boy. His father and two older brothers were killed in battle. He later left the order to become a professional painter. Both Kanō Motonobu and Kanō Eitoku have been suggested as his possible teachers, but there is no evidence to support these suppositions.

In an inscription on a portrait of him painted by his son, Yūshō wrote that he would have liked to remain a warrior rather than become an artist, yet his talent was well appreciated in his own day. His patrons included Toyotomi Hideyoshi, Emperor Go-Yōzei, and the great Kyoto Zen monasteries Kenninji and Myōshinji.

The present two hanging scrolls were originally among the twelve panels on a pair of screens. Zen understatement is their keynote. Much of the paper is left bare; the soft forms created by Yūshō's washes seem to dissolve here and there in the mist-filled space suggested by the empty paper. Yet Zen restraint is accompanied by dashing Momoyama boldness in the sweeping vertical branch at the left in *Long-Tailed Birds*. The concentration on a few large elements near the picture plane also distinguishes this from Muromachi painting.

Tokugawa Ieyasu established a dynasty of military dictators that survived for over two hundred and fifty years, a remarkably long period of peace in a country so frequently ravaged by civil war. He built his capital at the castle town of Edo (modern Tokyo); the Emperor remained a ceremonial puppet in Kyoto.

Following his victory at Sekigahara in 1600, Ieyasu worked diligently until his death to establish a totalitarian feudal system that would insure the continuing succession of his heirs. Men were compelled to pursue their fathers' occupations. Travel within Japan was restricted; foreign travel was punishable by death. Shipping was limited to coastal vessels unable to sail the open sea. An endless series of edicts regulated every aspect of Japanese life; the status quo was to be maintained at any cost.

To prevent rebellion, the government required each Daimyo to spend half the year in attendance at Edo under the surveillance of the secret police. During the other half year spent in his home province, his wife and eldest son were left in Edo as hostages. Daimyo were not allowed to stockpile weapons.

European ships were restricted to the two ports of Nagasaki and Hirado in southern Kyūshū in 1616. The English abandoned their severely curtailed trade with Japan in 1623. Spanish ships were forbidden to land in Japan after 1624. Edicts of 1633 and 1639 permanently confined Chinese residents to the city of Nagasaki. The Portuguese were excluded in 1639. A few tenacious Dutch merchants convinced the government that as Protestants they had nothing to do with Catholic missionaries or Spanish and Portuguese colonizing. They managed to remain in Japan under tight control. After 1641 their ships were restricted to the port of Nagasaki, and the Dutch staff of the trading station was confined to the artificial island of Deshima in Nagasaki harbor. Regarding them as a possible source of seditious ideas, the Japanese government banned Dutch books; not until the latter half of the Edo Period were they gradually tolerated. Japanese scholars undertook the awesome task of creating dictionaries, which allowed them to translate Dutch books and thus gain a rudimentary knowledge of Western medicine and science.

The Tokugawa regime installed Confucianism as its official doctrine but reinterpreted these Chinese ethical precepts to suit its own purposes. Family loyalty, the core of Confucian morality, was

held less obligatory than absolute obedience to one's feudal superior.

The government divided Japanese society into four classes: samurai, farmers, artisans, and merchants. The samurai were notoriously inept at finance and pretended disdain for money. Although they held merchants in contempt, the various Daimyo and even the Shogun found it necessary to borrow money and sometimes became hopelessly in debt to the merchants. But since edicts cancelling these debts were met by refusals to lend more money, the warriors were forced to tolerate and appease the merchants. The most significant social development of the Edo Period was the rise of the merchant class. For the first time in Japanese history, merchants became important patrons of the arts and some of the most progressive painting in the Edo Period took place under their patronage.

The Kanō School

The more conservative side of Edo Period painting is represented by the Kanō School, the official academy of the Tokugawa Shogun and most of the Daimyo. The school, in which most Edo artists trained, had been founded in the Muromachi Period by Kanō Masanobu (1434–1530), head of the Ashikaga *e-dokoro*. Masanobu was the son of a samurai and a lay member of the Hokke (Nichiren) Sect. His family name derived from that of the village in Izu Province where he was born. Masanobu's painting style was more crowded and stereotyped than those of his *e-dokoro* predecessors and probable teachers, Shūbun and Sōtan.

Masanobu's son and pupil, Kanō Motonobu, was a much more innovative painter than his father. He developed a type of large-scale, close-up, bird-and-flower composition that paved the way for Momoyama Period painting. Motonobu was awarded the title of *hōgen*, an honorary title bestowed on favorite artists by the Shogun. He executed many commissions for major Zen monasteries in Kyoto, an indication of his prestige as well as of the secularization of Zen painting after the fifteenth century. His masterwork, the superb series of sliding-door paintings in the Reiun-in sub-temple of Myōshinji, was painted in 1543.

After the death of his two older brothers, Kanō Shōei (1519–92), Motonobu's third son, inherited leadership of the Kanō School. Shōei was not a significant artist, but he was the father of Kanō Eitoku, the greatest painter of the Momoyama Period. Eitoku's grandson, Kanō Tanyū, was the most famous Kanō artist of the Edo Period.

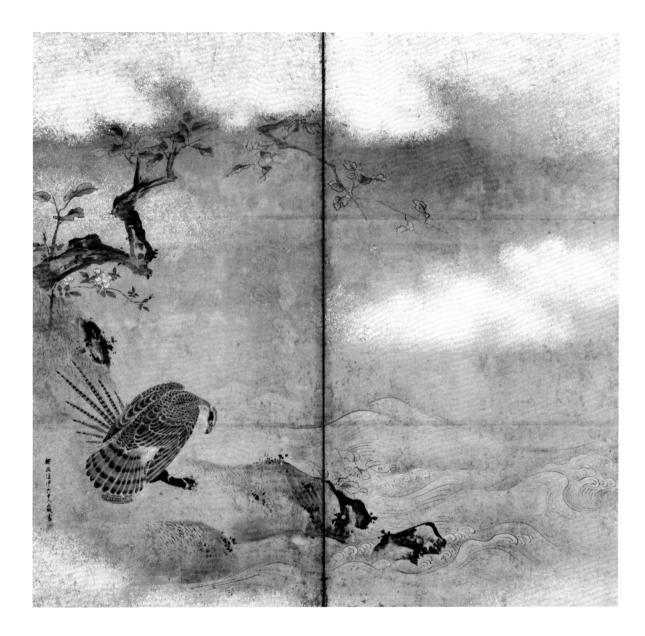

32

4 HAWK AND PHEASANT

Kanō Tanyū (1602–74)

Two-fold screen.
Ink and light color on paper, 71½ x 74 inches.

Signed (lower left): Tanyū Hōin Rokujūsai Ga (Painted by Tanyū, "Seal of the Law," an honorary title, sixty-two years old). Seal (calabash gourd–shaped, relief): Morinobu (Tanyū's given name; Tanyū, like the names by which we know most Japanese painters, is an art name).

Published: *Art News* (October, 1967), p. 59

Tanyū's father, Kanō Takanobu, took him from Kyoto to Edo in 1612 for an audience with Tokugawa Ieyasu. Five years later Tanyū renounced his succession to leadership of the main branch of the Kanō School in Kyoto in order to serve the Shogun in Edo. The government gave him an estate at Kajibashi and appointed him Painter-in-Attendance in 1621. He traveled to Kyoto in 1626 to supervise Kanō artists working on the cycle of wall and sliding-door paintings at Nijō Castle, the palace occupied by the Shogun during his ceremonial visits to the Imperial court.

Tanyū himself painted the huge *Pine Trees* in the main audience hall at Nijō Castle, using Kanō Eitoku's paintings as his models. *Pine Trees* is powerful and dignified but lacks the splendor of Eitoku's work.

Unlike the Nijō Castle *Pine Trees* with its heavy color and gold leaf, this two-panel screen of a *Hawk and Pheasant* is essentially a monochrome painting with ink and light color washes. The semi-transparent washes of vegetable dye mixed with water and glue are used like ink washes and the original ink brush strokes show through. Every stroke in a monochrome painting is irrevocable: the artist cannot make changes as he goes along.

With the lively movement of its breaking waves, *Hawk and Pheasant* is far more subtle and appealing than the many doctrinaire pictures of legendary Chinese sages that Tanyū and other Kanō artists painted for the Shogun and Daimyo. The self-consciously exaggerated black outlines in such works often seem tiresome today, although this line was a famous trademark of the Kanō School. Called *kōroku-egaki* ("barbed line"), it was said to embody high moral principles.

Hawk and Pheasant's "one-corner composition," in which most of the elements are arranged below a diagonal in the lower left, comes from the Southern Sung Academy through Ming and Muromachi interpretations.

The subject of this painting was extremely popular with Japanese warlords, who loved to hunt with falcons.

The Kaihō School

The Kaihō School was small and not nearly so influential as the vast, prestigious Kanō School. Although the school survived until the end of the Edo Period, the work of later artists rarely achieved the brilliance of its founder, Kaihō Yūshō, and it has faded into obscurity.

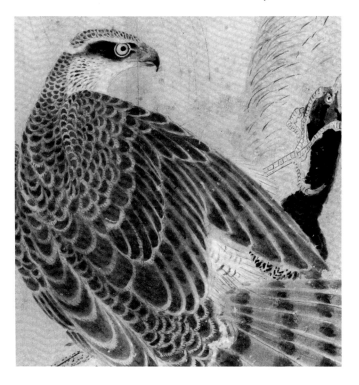

5 FUKUROKUJU

Kaihō Yūsetsu (1598–1677)

Hanging scroll.
Ink on paper, 13¼ x 6¼ inches.

Signed (lower right): Kaihō Yūsetsusai. Seal (vertical rectangular, relief): Kaihō.

Kaihō Yūsetsu was trained by his father, Kaihō Yūshō. Yūsetsu continued the family tradition in Kyoto but, perhaps inevitably, came under the influence of the powerful Kanō School. The style of drawing in this little figure is pure Kanō. If it were not for Yūsetsu's signature and seal, one would not hesitate to attribute this work to one of Kanō Tanyū's followers, such as Kanō Tsunenobu (1636–1713). The face of the figure is exactly like those in countless ink paintings ascribed to Tanyū; the freer, broader treatment of the drapery is like that of Tanyū's younger brother, Kanō Naonobu (1607–50).

In spite of such eclecticism, or perhaps because of it, Kaihō Yūsetsu achieved considerable renown in his own day, and his patrons included members of the Imperial court. Seeking the favor of the Shogun as well, Yūsetsu eventually moved from Kyoto to Edo. He was succeeded as head of the Kaihō School by his son and pupil Kaihō Yūchiku (1654–1728), who returned to Kyoto and painted for two former Emperors.

Yūsetsu's subject in this little scroll is Fukurokuju, the God of Longevity. He is identified by his absurdly long head, and wears the robes of an ancient Chinese sage. Yūsetsu's drawing of the face admirably expresses the advanced age and spiritual contentment of the old man; there is a jovial twinkle in his eyes. Fukurokuju is one of the *shichifukujin*, "Seven Lucky Gods," household gods who evolved in Japan during the late sixteenth or early seventeenth century from Chinese antecedents. They were extremely popular with Edo Period merchants, artisans, and peasants, as well as with more aristocratic art patrons.

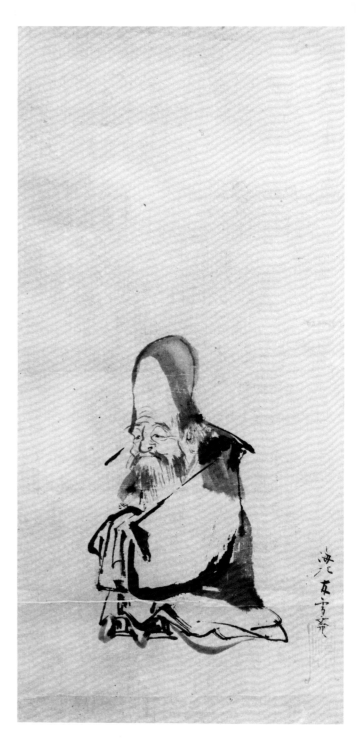

The Soga School

Soga Chokuan (died ca. 1614), a Momoyama Period artist who specialized in falcon paintings, was founder of the Soga School. The family name Soga suggests Chokuan's artistic descent from Soga Jasoku, a late fifteenth-century painter supposedly associated with the famous Zen priest Ikkyū Sōjun (1394–1481), forty-sixth abbot of Daitokuji. However, Jasoku is an extremely problematical figure; he is not mentioned in contemporary documents. Some authorities have suggested that he never existed, that Soga Chokuan invented him for the added prestige of lineage from an early painter. Soga Jasoku may have been the son of Ri Shūbun, a Korean painter who immigrated to Echizen Province in Japan in 1424, where he served warlords of the Asakura clan. Ri Shūbun is therefore called the ancestor of the Soga School.

Jasoku is supposed to have painted the superb sliding-door paintings of landscapes in the Shinju-an sub-temple of Daitokuji, Kyoto, but evidence for this attribution is lacking. Contemporary records related to Priest Ikkyū, in whose honor the Shinju-an was built, mention an artist named Bokkei but say nothing about Jasoku.

Soga Chokuan lived in Sakai, a flourishing semi-independent port city whose rich merchants were becoming important art patrons as early as the Momoyama Period. When nearby Osaka grew to commercial prominence later in the Edo Period, Sakai fell into oblivion, and the Soga School did not survive beyond its second generation.

6 MOONLIGHT OVER THE LAKE

Soga Nichokuan (active middle 17th century)

Pair of six-fold screens.
Ink and light color on paper, each screen 66½ x 148 inches.

Upper seal (occurs with a second seal at the lower left of the left screen and by itself at the lower right of the right screen; rounded square, relief): Nichokuan. Lower seal (at left only; square, relief): Sahei (Nichokuan's informal art name).

Instead of taking one of the two ideograms from his father's art name and combining it with another character to form his own art name in the usual manner of hereditary schools of artists, Nichokuan took his father's entire art name and prefixed "Ni" ("two") to become "Chokuan II." Like his father, Nichokuan lived in Sakai and specialized in painting falcons.

The two Chokuans were noted for paintings of hawks, and most of their work was no doubt devoted to that subject. Their merchant and samurai patrons would have requested the subject for which the artists were famous. (Naturally, forgers producing spurious Chokuan or Nichokuan paintings concentrated on birds of prey.) The present landscape screens are extremely unusual in their departure from the hawk as subject.

Moonlight Over the Lake reveals Nichokuan's difficulty in handling pictorial space. The transition from foreground to middle distance to background is unconvincing. Japanese painters could never create the illusion of space and atmosphere as well as Chinese painters could; they tended to compose in terms of flat pattern on the picture plane. But even so, Nichokuan seems to be struggling with problems of spatial transition already solved by Japanese *suiboku* artists in the early fifteenth century.

In a typical Nichokuan falcon painting, each bird is shown in rather flat profile at or near the picture plane. Only part of a tree or rock suggests a setting. There is no fully realized middle distance or background. The two large trees, the dominant motifs in this landscape, are presented in the same way. The figures, boats, and buildings are also flattened and brought close to the picture plane, but they lack the emphatic black accents of the two trees.

The shore, cottage, trees, and rounded peak in the tenth, eleventh, and twelfth panels are modeled after a similar passage in the famous 1491 Shinju-an *Landscape* attributed to Soga Jasoku. Nichokuan has, however, removed much of the space, the misty atmosphere, and the richness of detail. His boldly simplified, more decorative treatment of the landscape is in keeping with trends in Momoyama and early Edo Period painting.

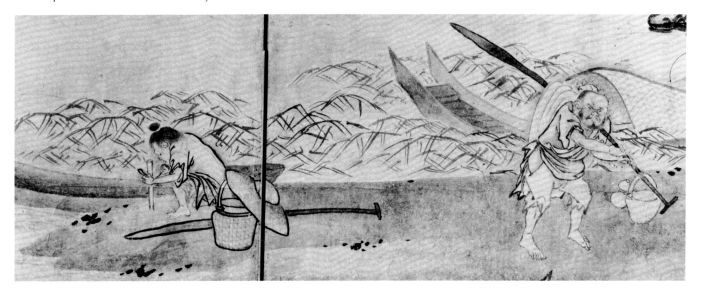

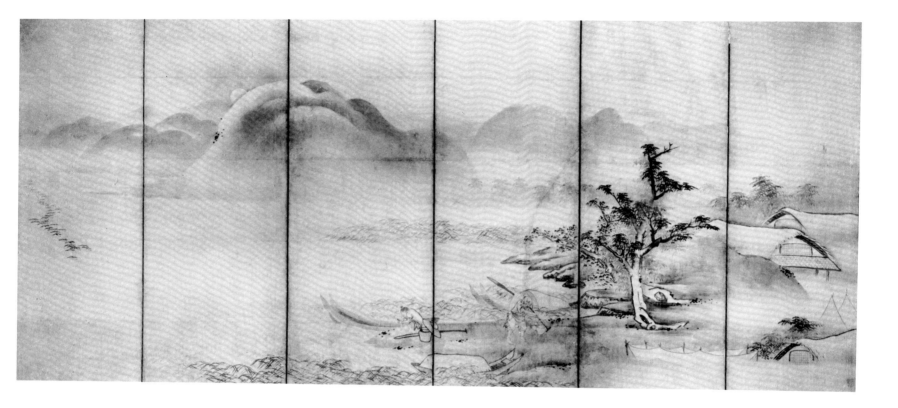

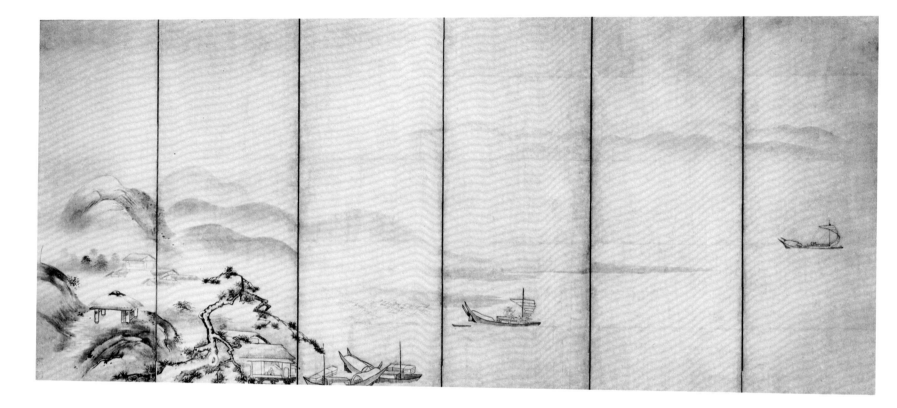

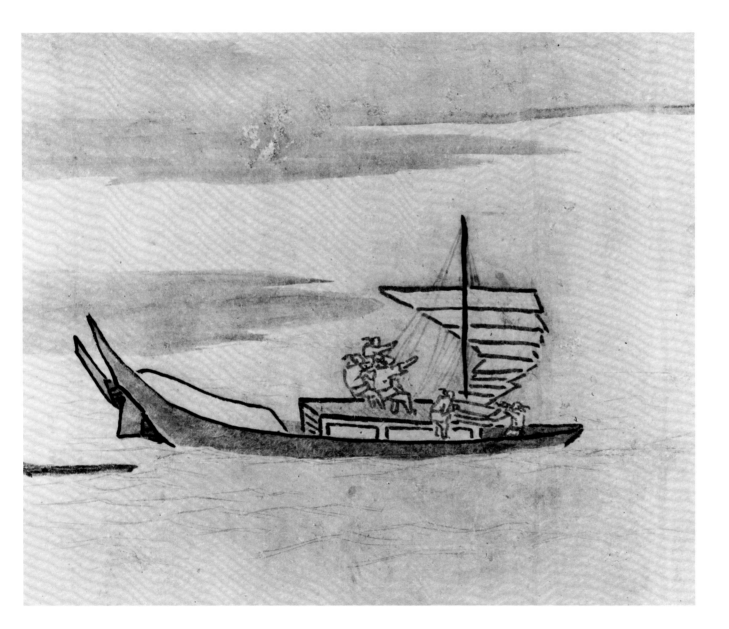

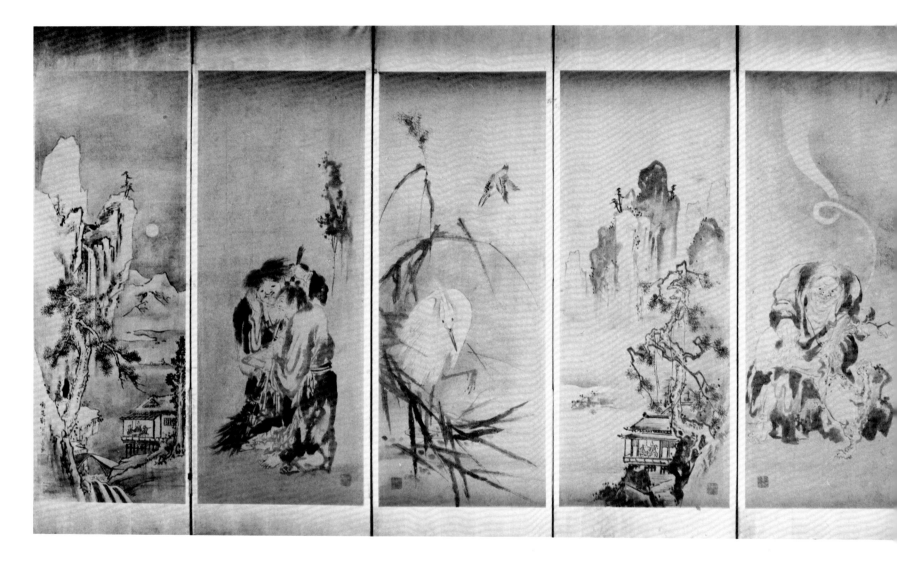

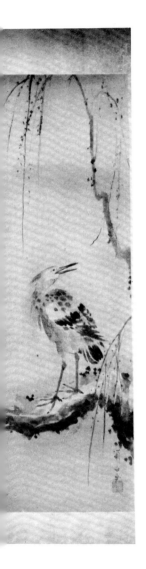

Soga Shōhaku (1730–81)

Six-fold screen.
Ink on paper, 67¼ x 134 inches.

Signed (lower right of right panel): Shōhaku Ga (Painted by Shōhaku); (lower left of left panel): Jasokuken Shōhaku Ga (Painted by Jasokuken, one of Shōhaku's art names, literally "The House of Jasoku," in reference to Soga Jasoku, Shōhaku). Seal (appearing below each signature and independently at the lower left or lower right of each unsigned panel; square, intaglio): Jasokuken Shōhaku.

Soga Shōhaku was definitely not connected with the Soga School of Chokuan and Nichokuan. He was an independent artist who, like them, traced his imaginary artistic lineage from Soga Jasoku, as indicated by the art name Jasokuken, with which he signed this screen. Shōhaku lived in Kyoto and was probably born there of merchant parents, although he was once thought to have come from Ise, where a number of his paintings are preserved.

Shōhaku's works are now being celebrated by the Japanese art establishment for the very quality that once made them anathema to most Japanese critics: their bizarre eccentricity. "Fantastic art" is one of the current fads in the art world of Japan.

The peculiar, unworldly side of Shōhaku's work is most apparent where it is most appropriate: in figure paintings of strange characters from Zen or Taoist legend. The many Meiji Period forgeries of Shōhaku's work concentrate on this aspect of his style but reduce it to grotesque vulgarity.

Soga Shōhaku was a sound, capable painter who made a unique effort to revive Muromachi *suiboku* painting in the middle of the Edo Period. He had little success, for novelty and up-to-dateness were the qualities sought by patrons of his day. His attempts to catch the attention of the fickle Kyoto art public account for the bizarre quality of his work. Shōhaku envied the tremendous popularity of Maruyama Ōkyo (1733–95), whose realistic paintings he regarded as trivial. He said that patrons desiring real paintings should come to him while those content

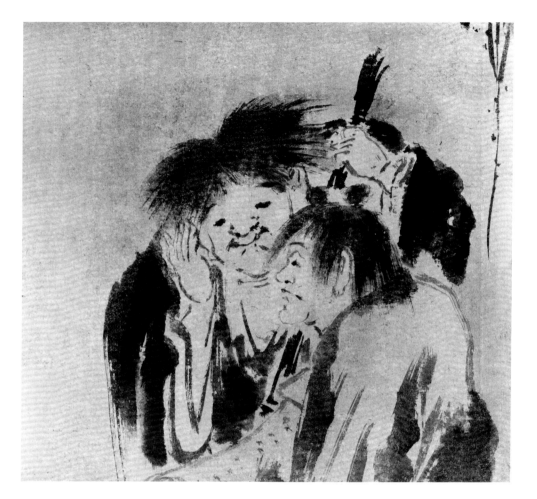

with mere renderings should go to Ōkyo. Shōhaku's eccentric behavior prompted some of his colleagues to call him mad.

Shōhaku received his early training under a minor Kanō School artist in Kyoto. He was perceptive enough to recognize that even the work of the best Kanō painters in his day had become sterile, in spite of the school's prestige. He rejected the Kanō style and turned to Muromachi ink-wash painting; Jasoku and Sesshū became his idols. He used their styles as a basis for a unique personal style. His work has wit, boldness, and an engaging self-consciousness, though it lacks the spatial and spiritual depth of its Muromachi antecedents.

Although found in earlier periods as well (see cat. no. 3), screens with a separate composition on each panel were especially popular in the second half of the eighteenth century. Painters of all schools produced them, but most have since been broken up for sale as separate hanging scrolls.

The subjects of the six compositions on the present screen are: Night Heron (a mottled gray variety seldom seen because it rests by day and hunts at night); Gamma Sennin ("Toad Immortal," one of the eight Taoist Immortals, identified by his three-legged toad); Landscape in Muromachi Style; White Heron, Kingfisher, and Reeds; Kanzan and Jittoku (Han-shan and Shih-te, legendary Zen eccentrics of the T'ang Dynasty, identified by their disheveled hair, robes, scroll, and broom); Moonlight Landscape in Muromachi Style.

The Ukiyo-e School

Woodblock prints from the latter half of the Edo Period were the first kind of Japanese art to become known in the modern West. Europe accidentally discovered Ukiyo-e prints in the middle of the nineteenth century when a shipment of Japanese export porcelain was unloaded at Paris. The importer noticed colorful designs on the packing material, which turned out to be woodblock prints. Although considered wastepaper in Japan at the time, the prints created an immediate sensation in Europe. Their striking designs and bright colors were refreshingly different from the somber browns of mid-nineteenth-century European paintings. Ukiyo-e prints were a major influence on the development of post-Impressionist painting.

Japanese collectors despised Ukiyo-e prints as vulgar expressions of lower class taste; dealers were delighted to sell them in Europe and America. Japan was soon stripped of all but the latest and poorest prints. Since World War II, however, the Japanese have been actively studying and collecting Ukiyo-e prints.

Unfortunately, the initial impact of Ukiyo-e prints has not entirely worn off in the West and they are still regarded as characteristic of Japanese art. They have enchanting designs and record fascinating aspects of Edo Period society, but as art they are a mere mechanical by-product of one school of Edo Period painting.

Ukiyo-e prints were the popular, mass-produced version of Ukiyo-e paintings, manifestations of a lively Edo Period sub-culture known as the Floating World. The term *ukiyo* had been used since the Fujiwara Period to describe a Buddhist concept suggesting the transitory and miserable nature of life in this world. Early in the seventeenth century it underwent a satirical transformation and came to suggest the pleasures of the flesh. It referred specifically to the sub-culture of the courtesan districts and Kabuki theaters in Edo, Osaka, and Kyoto. It came to mean "stylish," "sexy," and "modern," but always with its original meaning ironically in the background.

Each of the three largest Japanese cities had walled-in red-light districts licensed by the Tokugawa government. A cult of romantic excitement revolved around the districts' courtesans and the Kabuki actors, the two main subjects of Ukiyo-e paintings and

prints. Rich merchants bought fine paintings of courtesans to commemorate their visits to the licensed districts, and their clerks bought woodblock prints to enjoy the Floating World vicariously.

Courtesan prints were the pinups of their day, although the young women were nearly always shown fully clothed. In fact, since a courtesan's allure depended on her selection of kimonos and hair styles, courtesan prints served as fashion plates consulted by women all over Japan. One-third of Ukiyo-e print production consisted of graphically erotic prints, but, since the naked body was taken completely for granted in Japan, even these usually showed lovers fully clothed with their kimonos parted to display exaggerated pubic areas.

Kabuki, the popular theater of Edo Period Japan, was a great favorite of the masses in Edo and Osaka; its actors were a principal subject of Ukiyo-e prints. Rich merchants loved Kabuki, and even samurai went to see it. Many of the actors were male prostitutes, and the promise of romantic love added to the attraction of the Kabuki theater. Homosexuality had always been common among samurai, Buddhist priests, court nobles, and playboys.

Kabuki began in 1603 when Okuni, a former Shintō priestess from the Grand Shrine at Izumo, performed dances and mimes with a small troupe on the dry east bank of the Kamo River in Kyoto. Groups of Kyoto prostitutes began to stage similar performances, but fights among rival suitors in the audiences prompted the Tokugawa government to ban women from the stage in 1629. As soon as women were banned from Kabuki, young men took their place. Young male prostitutes called *wakashu* performed dances and skits to attract business; all but grown men were banned from the stage in 1652.

The first of the *ukiyo-zōshi*, popular novels about the Floating World, was published in 1682 under the title *The Man Who Spent His Life in Love*. There were fifty-four chapters, in parody of Lady Murasaki's *Tale of Genji*, Japan's classic eleventh-century novel of courtly love. The author, Ihara Saikaku (1642–93), lived in Osaka; he was a Kabuki critic, *bunraku* ("puppet theater") playwright, calligrapher, and *haiku* poet, as well as a successful popular novelist. The term *Ukiyo-e* ("Floating World Pictures") for paintings, prints, and book illustrations of courtesans or Kabuki actors came into vogue at about the same time the first *ukiyo-zōshi* novel appeared.

Ukiyo-e painting style developed from a tradition of early Edo Period genre painting (*fūzoku-ga*) that originated in the late Muromachi Period and continued through the Momoyama Period. Genre painting was not entirely new in the Muromachi Period; it was simply a matter of emphasis. Yamato-e narrative handscroll paintings of the Kamakura Period frequently included genre elements, but not as the main subject. They merely provided familiar, believable settings for the stories. By the end of the Muromachi Period, however, paintings with genre scenes as their main subjects began to appear, indicating a significant shift in social attitudes. The heroes of Yamato-e and Tosa scrolls were noblemen, warriors, or famous Buddhist priests. The figures in *fūzoku-ga* were *chōnin* ("city dwellers"): members of the merchant and artisan classes and even social outcasts such as prostitutes and gamblers.

The Kanō School led the development of *fūzoku-ga*. The anecdotal Japanese figure subjects, fine outline, and bright color of *fūzoku-ga* derived from the Kamakura Yamato-e and Muromachi Tosa painting elements that the Kanō School had employed, along with its regular "Chinese style," since Motonobu's time.

The first major artist of Ukiyo-e was Hishikawa Moronobu (ca. 1625–94). Illustrations for the first *ukiyo-zōshi* were drawn by its author, Ihara Saikaku, but when a pirated edition appeared in Edo, Moronobu did the illustrations. His paintings and prints perfectly convey the spirit of the Floating World. Beginning with Moronobu, many superb Ukiyo-e artists rose and fell in rapid succession. The Floating World was fickle; only the fad of the moment caught the fancy of the *chōnin*.

8 WISTERIA MAIDEN (FUJI ONNA)

Kitao Masayoshi (1764–1824)

Hanging scroll.
Ink and color on silk, 35¾ x 11¾ inches.

Signed (lower left): Kitao Sanjirō Masayoshi Hitsu (Painted by Kitao Sanjirō Masayoshi; Kitao is the artist's adopted family name or school name; Sanjirō and Masayoshi are two of his art names). Seal (round, relief): in the form of a *mitsudomoe* (three circled commas, a type of *mon* or crest).

Published: Narazaki Muneshige (ed.), *Zaigai Hihō: Nikuhitsu Ukiyo-e* [Japanese paintings in Western collections: Floating World paintings] (Tokyo, 1969), p. 71.

Kitao Masayoshi and Kitao Masanobu (1761–1816) were the two best pupils of Kitao Shigemasa (1738–1820), founder of the Kitao School of Ukiyo-e. Masayoshi came from an extremely humble background: his father made *tatami*, the thick straw mats that line the floor of a Japanese house. After a period of training under Shigemasa in the early 1780's, Masayoshi emerged as a skillful, sophisticated Ukiyo-e artist. Not content to work solely in one style, Masayoshi experimented with other styles in the late 1780's. From a study of Yamato-e, Chinese academic painting, and European engravings, he developed a unique abbreviated style for book illustrations. In 1794 he was appointed Painter-in-Attendance to the Daimyo of Tsuyama. He marked the increase in status by changing his family art name from Kitao to Kuwagata and took some training under Kanō Korenobu.

Wisteria Maiden is in Ukiyo-e style and is signed with the family art name Kitao. It dates from Masayoshi's Ukiyo-e period, sometime between the early 1780's and 1794. The firm, even line, bright colors, bold patterns, gorgeous kimono, and splendid isolation of the figure are typical of Ukiyo-e, as is the use of a *bijin* ("beautiful young woman") as the subject of a painting. The poem above the figure is not accompanied by a signature or seal and was probably written by Masayoshi himself. Verses on Ukiyo-e paintings or prints are usually satirical and frequently erotic, though their puns and allusions are often obscure today.

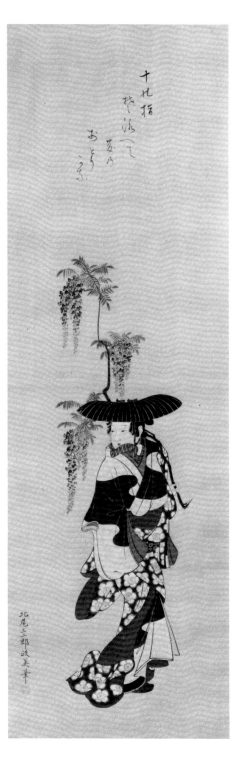

Tō no yubi	Ten fingers
Soroete	Arranged for
Fuji no	The wisteria
Odori	Dance
Ka na	Oh!

The Wisteria Maiden dance is one of the most popular in the traditional repertoire and is still frequently performed.

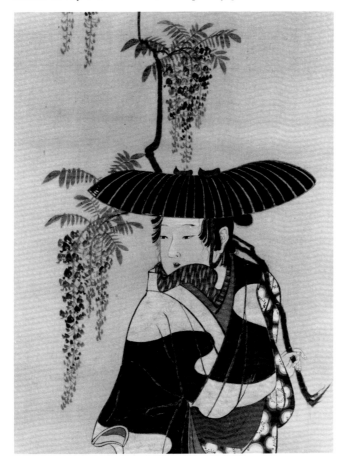

Rimpa, the Sōtatsu-Kōrin School

The most original and uniquely Japanese school of Edo Period painting was Rimpa ("rin" from "Kōrin," "ha" meaning "school"), the art of Sōtatsu, Kōrin, and their followers. The patrons of this school were an unprecedented combination of wealthy merchants and retired Imperial princes. Rimpa was an art of tremendous creativity and vitality. Like Tosa painting, it borrowed heavily from the Yamato-e tradition. Unlike Tosa, it employed the borrowed elements for the creation of an entirely new style. Sōtatsu-Kōrin painting is Japanese painting at its best, largely free of foreign influence, philosophical freight, or narrative content. It is painting as painting, pure design, the formal organization of colors and shapes, for which its subjects, often taken from classic court poetry, provide points of departure.

Tawaraya Sōtatsu was active in the early seventeenth century. Since he was not affiliated with the large Kanō or Tosa schools nor involved with literati painting, which celebrated the artist and his personality, little was recorded about his life. Even his birth and death dates are unknown; yet he is one of the key painters in the history of Japanese art. Only three entries in contemporary documents mention him. He was commissioned to repair the *Taira Sutras* at Itsukushima Shrine in 1602. The restoration of these Fujiwara Period Buddhist handscrolls would only have been entrusted to a well-established craftsman. In 1630 he was commissioned to make a copy of the *Saigyō Monogatari*, a famous set of Yamato-e narrative handscrolls of the Kamakura Period, and to paint three pairs of screens for the retired Emperor, Go-Mizunoo, an indication of the high esteem in which he was held.

Sōtatsu's unique painting style was influenced by Honnami Kōetsu (1558–1637). Though a sword appraiser by profession, Kōetsu became one of the three greatest calligraphers of his day. He was also a skilled potter, lacquer artist, landscape gardener, and tea master. His designs juxtaposed abstraction and representation, and varied shapes, colors, and textures in bold and imaginative ways. His innovations strongly influenced the techniques and principles of Japanese design. On his estate at Takagamine in the wooded hills north of Kyoto, Kōetsu established a colony of lacquerers, potters, metal workers, paper makers, scroll mounters, and other craftsmen to execute the designs he created.

Sōtatsu seems to have begun his career painting designs on fans; his family art name, Tawaraya, was the name of a Kyoto fan shop. Sōtatsu must have worked with Kōetsu at Takagamine; the two men collaborated on a number of poem-picture handscrolls; Sōtatsu's painted or printed background designs formed a perfect complement to the poems from old court anthologies written in Kōetsu's superb calligraphy.

Sōtatsu's commissions to restore the *Taira Sutras* and copy the *Saigyō Monogatari* exposed him to good Fujiwara and Kamakura Yamato-e, and it became his prime source. His fan paintings frequently recreated passages of Kamakura Period handscrolls. In his major works, he went beyond re-creation and assimilated Yamato-e into a bold new decorative style. His courtiers and attendants, warriors, carriages, oxen, and landscape elements were based on motifs from Kamakura Period Yamato-e narrative handscroll paintings but were used in an entirely new way: they were increased in size and rendered broadly and decoratively, becoming flat forms arranged in bold, lyrical designs with brilliant, harmonious color combinations. Sōtatsu's clever distortions of familiar forms for the sake of emphasis and design have a good-natured humor about them.

Sōtatsu often used a technique called *tarashikomi* ("dripping-in"). Ink or color was pooled into an earlier application of ink or color not yet dried. *Tarashikomi* became one of the hallmarks of the Sōtatsu-Kōrin style.

Sōtatsu's use of elements from Fujiwara and Kamakura painting and Kōetsu's reuse of poems from Fujiwara court anthologies are reflections of a revival of interest in classical court culture during the first half of the seventeenth century. Noblemen and, for the first time, rich merchants of refined taste practiced the old courtly pastimes of poetry writing, moon viewing, and incense guessing, often combining them with the tea ceremony that had developed in the Zen and warrior environment of the Muromachi Period.

The Rimpa School was named after Ogata Kōrin (1658–1716), who was better known than Sōtatsu during the second half of the Edo Period. The term *Rimpa* does Sōtatsu an injustice, for he and

Kōetsu originated the new style. Kōrin merely continued it, though with unquestioned brilliance.

Kōrin's family exemplified the wealthy, cultured merchants who were creating their own aesthetic milieu in the late seventeenth and eighteenth centuries. The Ogata family ran a flourishing silk fabric shop called Kariganeya. They supplied fine kimonos to Kyoto courtiers and warriors as well as rich merchants. Kōrin's great-grandfather had married the daughter of Honnami Kōetsu. Kōrin's grandfather was interested in calligraphy and the tea ceremony; he became involved with Kōetsu's art colony at Takagamine. He collected works by Kōetsu and Sōtatsu that remained in the family and provided inspiration for Kōrin. Kōrin's father was an amateur painter and calligrapher as well as an avid Nō drama fan.

As was the Japanese custom, family leadership and operation of the business went to Kōrin's older brother. Kōrin pursued a life of refined pleasure with a large inheritance he received at the age of thirty. He became a lifelong friend of some court nobles in the Nijō family. However, he soon squandered his fortune on expensive courtesans in the Kyoto licensed quarters, just as the playboys did in the Floating World novels of his day. Forced to rely on his paintings for a livelihood, Kōrin achieved great success as an artist. Many court nobles and wealthy merchants became his patrons.

Banished from Kyoto in 1701 for breaking sumptuary laws prohibiting the use of certain luxury goods by the merchant class, Kōrin lived in Edo from 1704 to 1710, painting for rich timber merchants, warlords, and officers of the Japanese mint. In 1711 he was allowed to return to Kyoto, where he remained until his death.

Kōrin was the leader of a spectacular flowering of art during the Genroku Era (chronologically 1688–1703; culturally 1680–1740). The new patronage of rich merchants stimulated a magnificent creative outburst in painting and the decorative arts, and genroku is still a household word for "splendor." Designs from Kōrin's paintings passed to the various Japanese crafts, especially lacquer and ceramics, where they have been used to good advantage ever since.

The finest surviving work from Kōrin's formative period (Kyoto, 1697–1701) is the Iris Screens in the Nezu Museum, Tokyo. Almost minimal in approach, they show only a row of iris plants on an undifferentiated gold leaf background. But subtle orchestration in the plants' placement and slight variations in their basic dark blue and green color provide endless visual interest, strength, dignity, and joy.

Sōtatsu's art was Kōrin's main source of inspiration; he made direct copies of several Sōtatsu paintings. Works from Kōetsu's art colony in the Ogata collection and the ceramics of his younger brother Ogata Kenzan (1663–1743) also influenced Kōrin; through them his painting style was significantly affected by the conventions of craft design. Experience with fabric design at Kariganeya contributed to the development of Kōrin's superb sense of design. In spite of his decorative intent, Kōrin trained himself partly by sketching from nature.

Kōrin's masterwork, the pair of two-panel screens of Red and White Plum Blossoms in the Atami Museum, dates from his mature period (Kyoto, 1711–16). A curving, conventionalized brook of dark blue-gray tarnished silver leaf with gold eddies divides the composition. To the right is an old plum tree with red blossoms, to the left another with white blossoms, each against the plain gold leaf background. The characteristic Rimpa technique of tarashikomi articulates the surfaces of the trunks and branches. The plum trees and brook are boldly stylized, flat, decorative shapes. There is no pictorial space or atmosphere. Yet the form and growth of the old trees are well understood. The vitality of these plum trees comes from a kind of implied movement; they almost seem to be dancing. There is dynamic visual tension between the right and left halves of the composition.

9 WHITE CHRYSANTHEMUMS

Tatebayashi Kagei (active first half 18th century)

Folding fan–shaped painting, framed.
Ink and color on paper, 7¼ x 19 inches.

Signed (at left): Kagei. Seal (round, relief): undeciphered.

Published: Mizuo Hiroshi, *Sōtatsu Kōrin Ha Senmenga Shū*
[Collection of Sōtatsu-Kōrin School fan paintings]
(Tokyo, 1965), pl. 70.

Kōrin's younger brother Ogata Kenzan is remembered primarily as the most innovative potter of the Edo Period, but he was also a painter of considerable skill, taught by his older brother. Kenzan and Kōrin often collaborated on ceramics; Kenzan made the pots which Kōrin decorated, usually with iron-oxide black painting on cream-colored pottery. Kenzan moved to Edo from Kyoto in 1731 at the age of sixty-eight after apparently falling into disfavor at the Imperial court. He was accompanied to Edo by his patron, Prince Kokan, and continued to make pottery.

Tatebayashi Kagei was born in Kaga Province (modern Ishikawa Prefecture), where he was trained as a physician and served the local feudal lord. He went to Edo about 1736 and took painting instruction from Kenzan. Kagei specialized in decorative paintings of flowers in the manner of Sōtatsu and Sōsetsu (active mid-seventeenth century) as transmitted by Kenzan. Sōsetsu was a pupil of Sōtatsu who made a specialty of flower painting, which had formed only a small part of Sōtatsu's oeuvre.

Sōtatsu, Kōrin, Kenzan, and other Rimpa artists frequently painted folding fans. Other schools of painting used this format, but it was especially suited to the broadly rendered, decorative style of Rimpa. The fan-paper paintings were not always mounted on the folding bamboo frames of fans; sometimes they were mounted on hanging scrolls or in groups on screens. Mounted fans were often dismounted to save the paintings from wear and remounted as scrolls, put on screens, or kept flat in paper folders. *White Chrysanthemums* was never mounted as a fan; it bears no creases from radiating folds.

Kagei's paintings are rare today. He was noted for his daring use of color, as seen here. Arrangements of somewhat flattened flowering plants against plain gold leaf or paper backgrounds are standard in Sōsetsu paintings. The *tarashikomi* on the leaves of these chrysanthemums is a Rimpa trademark. The naive, almost childlike simplicity of the flowers on this fan surpasses even Kōrin in its modern feeling. Kenzan became a master of such abbreviated stylizations from his long experience decorating pottery. He passed this on to Kagei, who gave it his own personal twist in the almost Van Gogh–like flowers we see here.

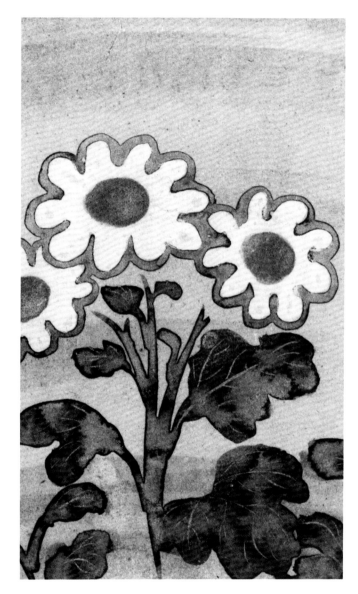

50

10 CHERRY AND MAPLE TREES

Sakai Hōitsu (1761–1828)

Pair of six-fold screens.
Color and gold leaf on paper, each screen 69 x 134 inches.

Signed (lower right of right screen): Uka Hōitsu Hitsu (Painted by Uka Hōitsu; Uka-an was one of Hōitsu's art names); (lower left of left screen): Hōitsu Hitsu (Painted by Hōitsu). Upper seal (round, relief): Bunsen (one of Hōitsu's art names). Lower seal (square, relief): Hōitsu.

Along with Tatebayashi Kagei, two other followers of Kōrin carried the Rimpa tradition into the next generation: Watanabe Shikō (1683–1755) and Fukae Roshū (1699–1757). Shikō was a Kyoto artist in the service of feudal lords of the Konoe family. Like most of the painters serving the military aristocracy, he was trained in the Kanō School, but after working with Kenzan during the period of the Narutaki kiln (1699–1712), Shikō changed his painting style from Kanō to Rimpa.

Roshū's father, Fukae Shozaemon, was an official of the Kyoto mint. Nakumura Kuranosuke, one of Kōrin's chief patrons and subject of the only actual portrait in Kōrin's oeuvre, was also an official of the Kyoto mint. This connection probably influenced Roshū's choice of a career as a Rimpa painter. He turned to the work of Sōtatsu for inspiration, just as Kōrin had done.

In view of Kōrin's great success, his many wealthy and influential patrons, and the tremendous impact of his style on the arts of his day, it seems incredible that his painting tradition ended so abruptly; Rimpa fell into complete disuse with the deaths of Shikō and Roshū in the middle of the eighteenth century. It remained dormant for half a century until its revival by Sakai Hōitsu, a feudal lord's talented dilettante son.

Because of the Tokugawa government's requirement that each feudal lord leave his wife and eldest son in Edo for half the year, Hōitsu, the second son of Sakai Tadatsugu, was born in Edo even though his father was lord of Himeji Castle in Harima Province (Hyōgo Prefecture). As was customary, the eldest son inherited leadership of the clan and responsibility for supervising its do-main. Hōitsu mastered the martial skills expected of a samurai: horsemanship, archery, and sword connoisseurship.

In 1793, at the age of twenty-eight, Hōitsu traveled to Kyoto and entered the Buddhist priesthood, a formality that allowed him to retire from active life and pursue his wide-ranging interests. He received religious instruction from Monnyō Shōnin at the rich and powerful Jōdo Shinshū temple of Nishi Honganji. After a short time he returned to Edo and took up residence in the Asakusa area, site of the Yoshiwara, Edo's greatest courtesan district. Like his idol Kōrin, Hōitsu pursued the women of the licensed quarters, though such activity was officially forbidden to members of the warrior class. Hōitsu was also a man of letters, a *haiku* poet who published ten volumes of poems, a fine calligrapher, and a talented musician and tea master.

Hōitsu's development as a painter was perhaps the most eclectic in the history of Japanese art. The Nagasaki School attracted his early attention; he studied under Sō Shiseki (1712–86; see cat. no. 16). He received Kanō School training from a minor late eighteenth-century artist named Eitoku. He next turned to the Ukiyo-e School, a seemingly odd choice for a samurai, since the Floating World sub-culture was held in official contempt. However, the choice was no doubt dictated by Hōitsu's interest in Yoshiwara courtesans, the staple subject of Ukiyo-e. Utagawa Toyoharu (1735–1814) was his Ukiyo-e teacher. Hōitsu later changed to the Realistic School and became a pupil of Maruyama Ōkyo's student Watanabe Nangaku (1767–1813). Finally the Nanga School painter Tani Bunchō (1764–1840), himself very much of an eclectic, advised Hōitsu to try the Kōrin style.

Hōitsu became the great champion of Kōrin. He copied many of the master's paintings and based his style on them. In 1815 he published two books on Kōrin's work: *Kōrin Hyakuzu* (One Hundred Paintings of Kōrin) and *Ogata-ryū Inpu* (Seals of the Ogata School). He held special observances in 1816 on the hundredth anniversary of Kōrin's death and erected a monument to his memory. He honored Kenzan with a similar monument and a book, *Kenzan Iboku* (Ink Paintings of Kenzan).

In 1809, at the age of forty-seven, Hōitsu built a painting studio in Edo and called it "Uka-an" ("Rain-Flower Hermitage"). From that time on he used the name of the studio as one of his art names.

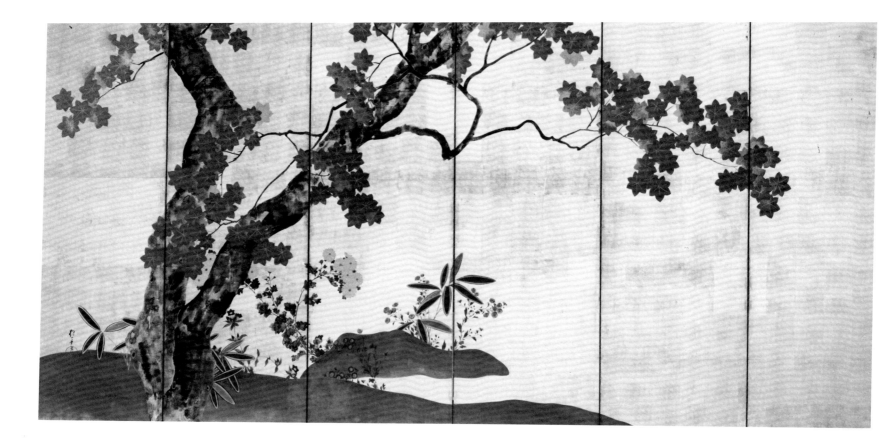

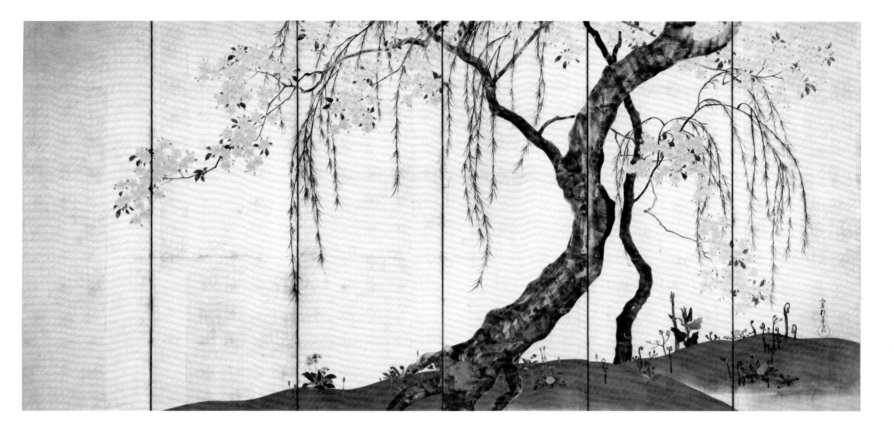

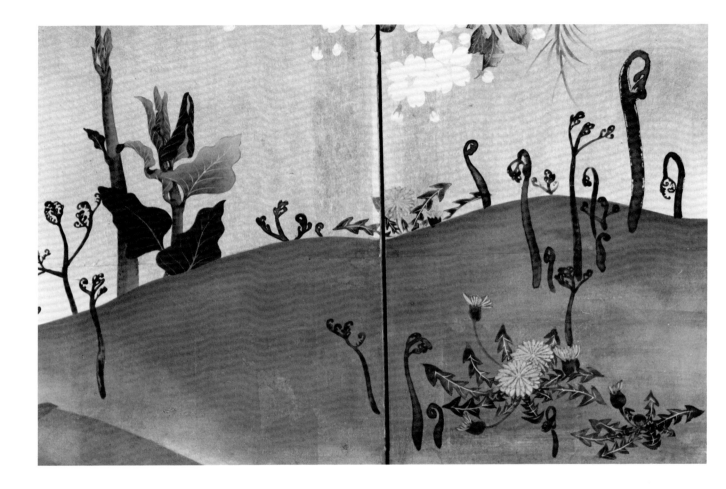

It appears in the signature on the right screen of the present pair. These magnificent screens are unusually powerful examples of Hōitsu's work. They have boldness and strength, elegance and dignity. They display the technical refinement for which Hōitsu was noted. He was a perfectionist in the selection and preparation of colors; his family wealth enabled him to spare no expense in their production. His fresh, bright color sense developed in part from his early Nagasaki School training. *Cherry and Maple Trees* has almost none of the prettiness or excessive sweetness that hampers much of Hōitsu's work. Still, one would never mistake these screens for a Kōrin painting. In place of the master's robustness there is a more static, cool, delicate perfection.

11 SPARROWS AND FLOWERS

Sakai Hōitsu (1761–1828)

Hanging scroll.
Ink and color on silk, 56¼ x 19 inches.

Signed (lower left): Hōitsu Hitsu (Painted by Hōitsu).
Seal (round, relief): Bunsen (one of Hōitsu's art names).

Three stalks of hollyhock and one stalk of lily are arranged in a single plane against the undifferentiated background—the standard Rimpa formula transmitted to Kōrin from Sōtatsu and Sōsetsu. The *tarashikomi* on the hollyhock leaves is also characteristic of Kōrin and his precursors. However, the insertion of the minute sparrows for contrast with the broad leaves and blossoms, as well as the overly refined precision of the entire painting, clearly distinguish Hōitsu's work from that of his predecessors.

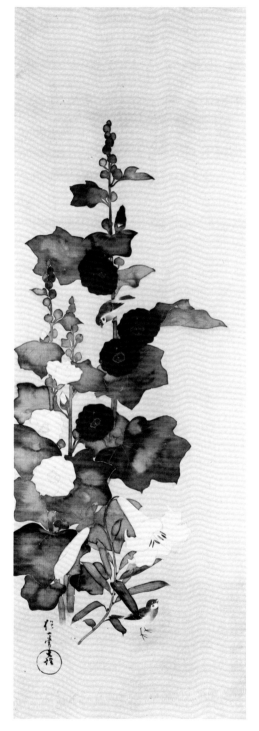

12 NARIHIRA AT UTSU NO YAMA

Sakai Hōitsu (1761–1828)

Hanging scroll.
Ink and color on silk, 42¾ x 17 inches.

Signed (lower right): Hōitsu Hitsu (Painted by Hōitsu).
Seal (square, relief): Uka (Uka-an was one of Hōitsu's art names).

Ariwara no Narihira (825–880), a son of the half brother of Emperor Saga (reigned 809–823), is one of Japan's Thirty-six Immortal Poets. His prowess as a courtly lover is said to have been second only to that of Prince Genji. Narihira is supposed to have written most of the poems in the *Ise Monogatari* (The Tales of Ise), a tenth-century collection of poetry and prose, which contains one hundred and twenty-five episodes, each constructed around one or more poems. It may have been based on diaries of his romantic adventures, although his name never appears in the stories; the hero is referred to only as "a man."

In the Utsu no Yama episode, Narihira has been banished from Kyoto. Accompanied by two old friends, he is on his way to live in some far-off place. At Mount Utsu (Utsu no Yama) in Suruga Province (modern Shizuoka Prefecture), the travelers are about to enter a dark and narrow pass densely grown with ivy and maples. They are lonely and unhappy; the forbidding pass reminds them of the bitter and uncertain future they face in exile. An itinerant priest going the opposite direction appears and asks them what they are doing on such a road. He turns out to be someone they have met before. Narihira writes a letter to his beloved in Kyoto and entrusts it to the priest for delivery. The letter contains the following poem:

> Neither while awake
> Nor in my dreams
> Beside Mount Utsu in Suruga
> Do I meet my love

Sōtatsu's use of episodes from the *Ise Monogatari* as subjects for paintings was part of the nostalgic revival of classic court culture in

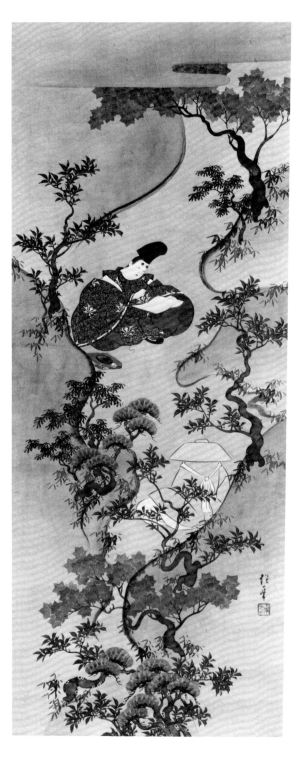

the early seventeenth century. Sōtatsu's famous *Ivy Lane* screens in a Japanese private collection (see Tokyo National Museum, *Rimpa* [Tokyo, 1972], no. 11) also refer to Utsu no Yama. Hōitsu illustrates it literally, while Sōtatsu alludes to it with ivy growing in a green and gold landscape abstraction.

Kōrin also used the Narihira theme frequently. His *Yatsuhashi* (Eight Plank Bridge) screens in The Metropolitan Museum of Art and his *Narihira Looking at Mount Fuji* cypress door painting in the Freer Gallery refer to incidents in the same episode of the *Ise Monogatari* as the Utsu no Yama passage.

Fukae Roshū's well-known version of Utsu no Yama, the *Ivy Lane* screen in the Umezawa Kinenkan, Tokyo, is based directly on a Sōtatsu *shikishi* ("poem card") painting, originally one of a large set illustrating incidents from the *Ise Monogatari*. In the Sōtatsu and Roshū versions, Narihira stands in an ivy-grown mountain pass watching the departure of a traveling priest while an attendant holds his horse.

Nick Carter has pointed out that the present Hōitsu version is based closely on a Kōrin prototype whose present whereabouts is unknown but which is reproduced in woodblock in *Kōrin Hyakuzu* from Hōitsu's drawing of it.

A seated Narihira is writing a letter while the priest waits nearby, his back to the viewer. Narihira wears his usual black-lacquered court cap while the priest wears a reed traveling hat. Kōrin and Hōitsu included the autumn maples mentioned in the story but left out the ivy that figured so prominently in the other versions. Hōitsu repeated this composition on a two-panel screen in a Japanese private collection (see Tokyo National Museum, *Rimpa* [Tokyo, 1972], no. 215).

13 FLOWERS AND TREES

Suzuki Kiitsu (1796–1858)

Pair of six-fold screens.
Color and gold leaf on paper, each screen 67¾ x 147 inches.

Signed (lower right of right screen, lower left of left screen): Seisei Kiitsu (Seisei is one of Kiitsu's art names). Seal (round, relief): Kiitsu.

The flattened arrangement of flowering plants near the picture plane on an undifferentiated background marks these screens as classic Rimpa: Sōtatsu, Kōrin, Shikō, and Hōitsu all used it; Sōtatsu's follower Sōsetsu made a career of it. Kiitsu here varies the formula by inserting two trees, a paulownia at the right and a cypress at the left; but the spatial relationship of the trees to the flowers is awkwardly handled; one feels that the trees are a disparate motif grafted onto an otherwise standard Rimpa flower painting.

The trees function as parentheses closing each end of the picture. It was conventional in pairs of landscape screens from the Muromachi Period onward to crowd both ends of the composition and leave the center largely open. Such landscape screens often attempted to represent all four seasons in a single vista, with seasonal changes subtle enough not to cause divisions in the scenery. In these screens Kiitsu refers to the seasons without systematic transition. Spring and summer flowers appear in the right screen while autumn flowers and pampas grass are seen in the left screen. A pair of screens, like a handscroll, is "read" from right to left. Winter is suggested by the snow on the branches of the cypress tree.

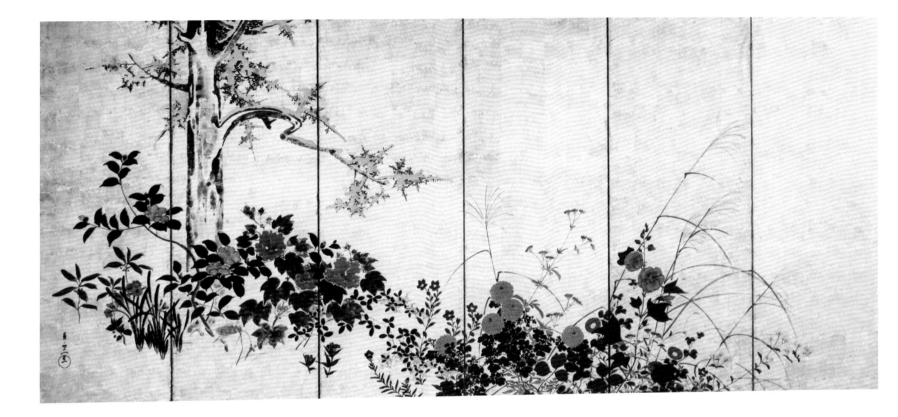

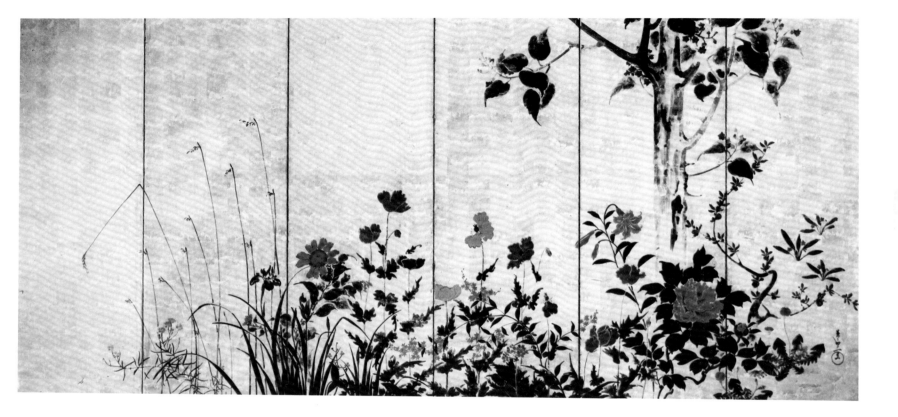

14 CRANES

Suzuki Kiitsu (1796–1858)

Six-fold screen.
Color and gold leaf on paper, 70 x 148½ inches.

Signed (lower right of right panel): Kiitsu Hitsu (Painted by Kiitsu). Seal (round, relief): Seisei (one of Kiitsu's art names).

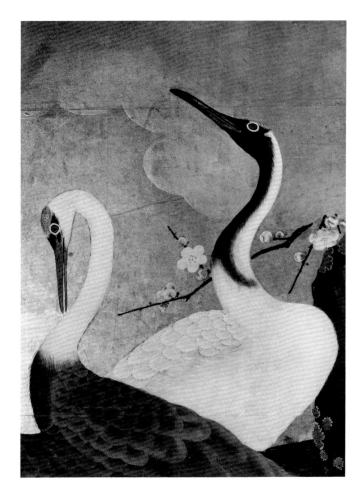

Suzuki Kiitsu was the most important of Hōitsu's four pupils. He came from Ōmi, the area around Lake Biwa, but moved to Edo and worked as a dyer. After being adopted as a son by Suzuki Reitan, a feudal retainer in the service of the Sakai family, Kiitsu served Hōitsu as a kind of secretary, receiving painting instruction from him as well as from Nakamura Hōchū (late eighteenth–early nineteenth century). Hōchū, a skillful *biwa* ("Chinese lute") player, was born in Kyoto but spent most of his career as a Rimpa painter in Osaka. He revived the Kōrin style in a bold, broad manner that contrasts sharply with Hōitsu's cool precision. Hōchū was especially good at the Rimpa *tarashikomi* technique.

Cranes like the ones shown nearly life-sized on this screen were once seen throughout the Japanese islands; today only a single colony survives, in a remote section of the coast on Hokkaidō, the large northern island. Since the Sennin (Taoist Immortals) are said to travel on the backs of flying cranes, the crane has always been an auspicious motif associated with longevity and immortality in China and Japan. Kiitsu here uses a Kōrinesque brook reminiscent of *Red and White Plum Blossoms* to unite this composition of cranes, young pines, blossoming cherry, bamboo, and clouds. The slightly cluttered appearance of the painting derives from Hōitsu's fondness for detail rather than from Kōrin's work. Kiitsu lacks Hōitsu's absolute technical precision but consequently suffers less from the prettiness that plagues many of Hōitsu's paintings.

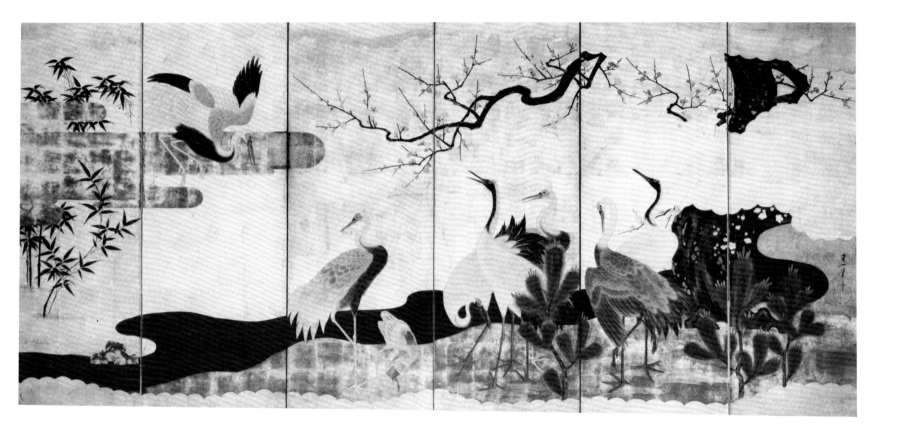

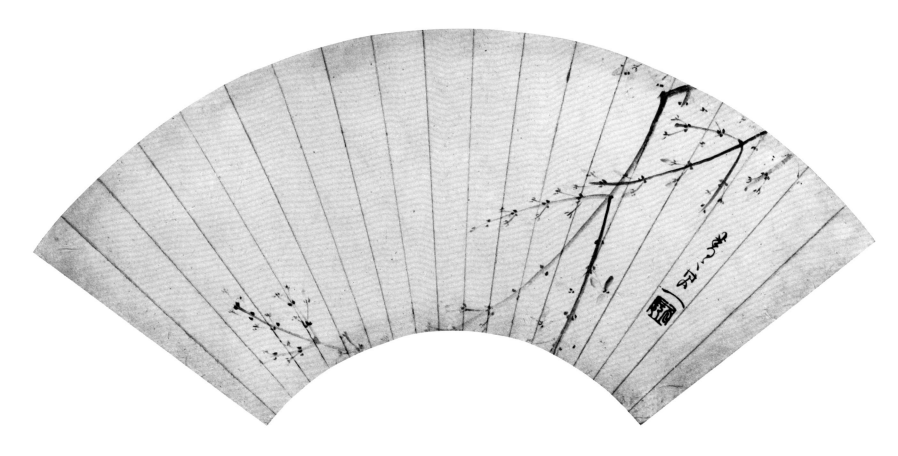

62

15 SEASONAL FLOWERS

Suzuki Kiitsu (1796–1858)

Seven folding fan paintings, separately framed.
Ink and color on paper, each 7⅛ x 20¾ inches.

Signed (near right or left side of each fan): Seisei Kiitsu
(Seisei is one of Kiitsu's art names). Seals (calabash
gourd–shaped, relief): undeciphered; (square, relief):
undeciphered.

These seven fan paintings were all once mounted as folding fans;
the creases are readily apparent. The fans have been removed from
their pivoted bamboo frames and mounted flat for better preserva-
tion.

All the many styles of Edo Period painting were available to an
artist of the early nineteenth century if he chose to use them. These
delightfully fresh and delicate little flower paintings hardly look
like Rimpa at all. Rimpa flowers usually have bright, opaque color
on the blossoms and strong *tarashikomi* on the leaves, as well as a
more decorative distribution within the composition. These flow-
ers reflect the Maruyama-Shijō School's realistic intent and the
Nanga School's interest in brushwork. The petals of the chrysan-
themums, with their lively outline of varying thickness and den-
sity, are reminiscent of a standard Nanga type derived ultimately
from the middle Ming artist Shen Chou (1427–1509). Several of the
fans, especially *Willow and Moon*, remind one of certain delicate,
semi-realistic brush sketches by Shijō artists. Only in the leaves on
the *Squash* and *Peony* do we find obvious *tarashikomi*. Yet the
squash itself seems to be fading into the mist; it is painted in an
ethereal manner entirely untypical of Rimpa.

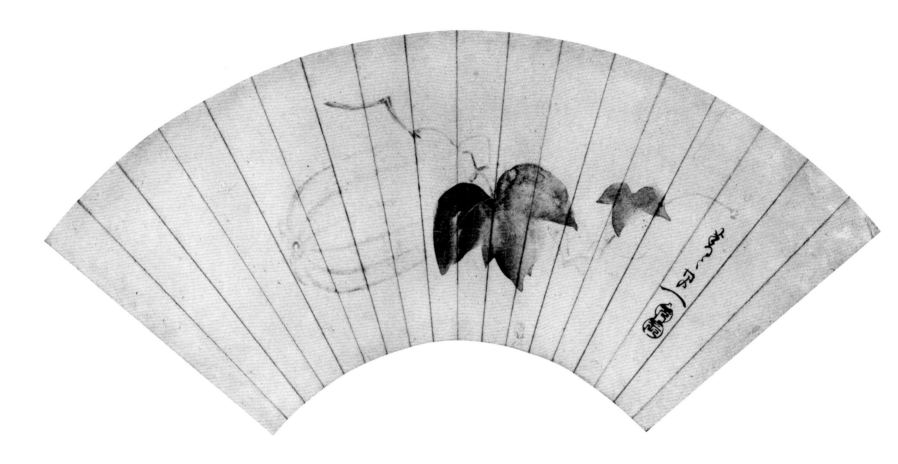

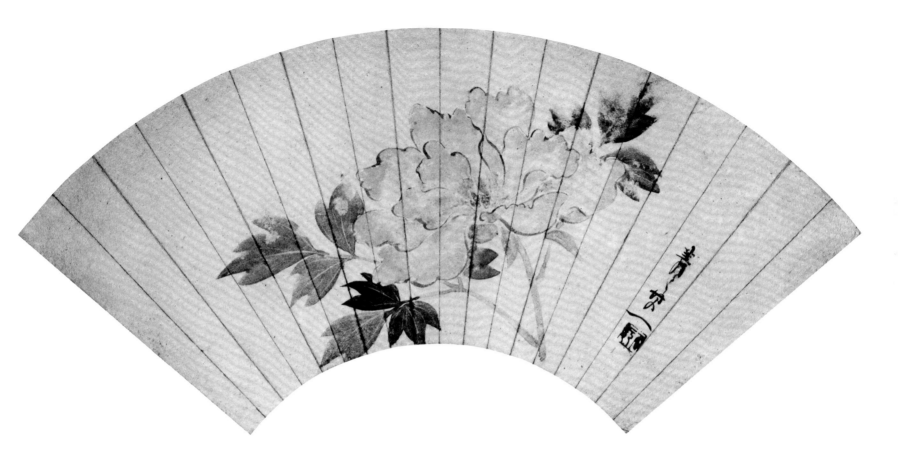

69

The Nagasaki School

With the fall of the Ming Dynasty in 1644, a number of Chinese scholar-officials, monks, and merchants fled to Japan rather than serve Manchu rulers. Most of them were confined to Nagasaki, whose Chinese colony and Dutch trading station were the only foreign settlements permitted in Japan under the isolationist policy of the Tokugawa government.

The Chinese immigrants in Nagasaki introduced two styles of painting new to the Japanese. Though essentially opposite in approach, the two styles were regarded in Japan as two aspects of the same school, and both became very influential. Japanese painters came to Nagasaki to study under Chinese artists and then spread the new type of painting to other parts of Japan. Many of these painters learned both of the two new styles, although art theorists in China thought only the literati style was valid. They considered brightly colored, realistic, professional painting to be mere artisan work, no better than the decoration of porcelain.

Nagasaki School designates the Japanese painters who concentrated on the more brightly colored and professional of the two new Chinese styles. This style was introduced to Japan primarily through the paintings of Shen Nan-p'in (Japanese: Chin Nampin), a professional painter invited to Japan by government officials who had heard of his work. Shen Nan-p'in arrived at Nagasaki in 1731 and returned to China in 1733. He specialized in slick, realistic bird-and-flower paintings in bright color. His work proved very popular in Japan and he continued sending paintings to Japanese customers after his return to China.

16 ROOSTER

Sō Shiseki (1712–86)

Hanging scroll.
Ink and color on silk, 43½ x 15 inches.

Signed (center left): Sō Shiseki Sha (Painted by Sō Shiseki), Shi (Four, probably indicating that the scroll was originally one of a set of four), Bannen, Rokujūsai (Late in Life, Sixty Years of Age). Upper seal (square, relief): Ka. Lower seal (square, relief): Tei (Katei was one of Shiseki's art names).

Sō Shiseki was born in Edo. From his early youth he was skillful at painting, but Ukiyo-e, so popular in Edo during his lifetime, held little interest for him. He traveled to Nagasaki instead and studied under Kumashiro Yūhi (1712–72), Shen Nan-p'in's best Japanese pupil. Yūhi was a native of Nagasaki, where members of his family worked as official interpreters of Chinese.

Shiseki subsequently studied painting with Sung Tzu-yen, a Chinese artist staying at Nagasaki. Two of the three ideographs in his art name, Sō Shiseki, derive from the Japanese pronunciation of his Chinese teacher's name, Sō Shigan.

After training in Nagasaki, Shiseki returned to Edo and became the leading exponent of Nagasaki School painting there. Sakai Hōitsu (see cat. nos. 10–12) was one of his many pupils.

The main subject of this painting is a *chabo*, a type of bantam cock prized in Japan for its handsome plumage. The carefully observed realism, tight drawing, and bright color are typical of Nagasaki School painting, as is the bird-and-flower subject matter. In spite of his almost excessively tangible rendering of every detail, Shiseki imbued his rooster with life and movement, something lesser artists of the Nagasaki School did not always manage to do.

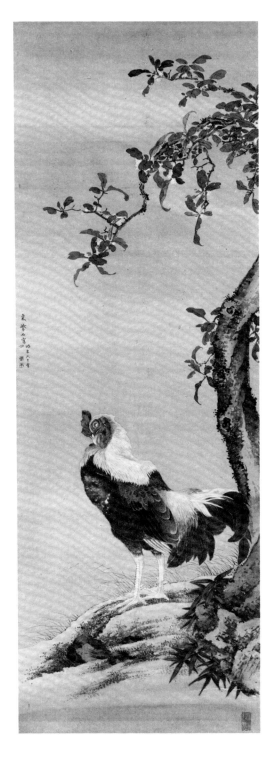

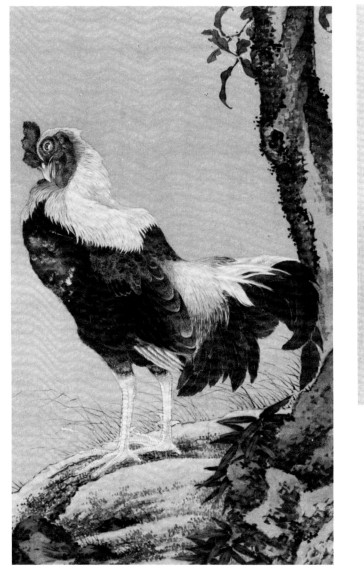

The Nanga School (Bunjinga)

Chinese monks fleeing the collapse of the Ming Dynasty brought an additional sect of Zen Buddhism, Ōbaku (Chinese: Huang-po), and another major school of painting to Japan. Itsunen (Chinese: I-jan) came to Nagasaki in 1644 and introduced the school of painting that had dominated Chinese art since the late thirteenth century: Bunjinga (Chinese: *wenjenhua*, "paintings by literary men"). The prestige and influence of the Kanō School had kept the literati style from gaining a secure foothold in Japan before this time. Watanabe Shūseki (1639–1707), a Japanese artist living in Nagasaki, studied literati painting under Itsunen. The style was gradually taken up by a number of other Japanese painters.

Bunjinga is also called Nanga (Chinese: *nanhua*, "southern painting"), a term derived from the theory of "Northern and Southern Schools" advocated by the late Ming painter and art critic Tung Ch'i-ch'ang (1555–1636). In this highly arbitrary scheme, the paintings Tung Ch'i-ch'ang disliked, professional and academic works, were relegated to an imaginary "Northern School"; paintings he liked, "amateur" works by scholar-officials and other literary men, were elevated to an imaginary "Southern School." The ideals of *wenjenhua* were established long before Tung Ch'i-ch'ang. The tradition had originated in the T'ang Dynasty and had developed in the Five Dynasties and Northern Sung periods. During the Yuan Dynasty, China's Mongol rulers had little interest in either art or the cultural heritage of their Chinese subjects. Partly in reaction to this, literati painting flourished among Chinese intellectuals and became the dominant form of Chinese art, a position it has maintained until modern times.

According to *wenjen* theory, a gentleman does not sell his paintings. He paints for his own pleasure and gives his paintings to friends. (In practice, many literati artists did rely on their paintings for a living; they gave them to patrons and received appropriate gifts in return.) The painting should never depict the mere external appearance of its subject; it should capture its inner essence and life-spirit. The brushwork should reveal the artist's personality. His knowledge, courage, refinement, wit, and mood should be apparent in the painting. Excellent calligraphy was expected. The same brush and ink used for calligraphy were also the basic tools of painting. The artist learned to paint by studying and copying the work of earlier masters until ready to create his own individual style.

Literati painting technique involved a sort of additive process. Dots and dabs of dilute ink were applied repeatedly, gradually building forms and texture on top of the faint lines and wash areas used to lay out main elements of the composition. In the "professional" style, the lines, strokes, and wash areas were more distinct and displayed technical mastery which literati painting deliberately avoided.

Nanga activity in the middle of the seventeenth century had little impact on the development of Japanese painting. During the first half of the eighteenth century, however, interest in literati painting began to spread. The dissemination was helped by the importation and reprinting of Chinese painting manuals.

Gion Nankai (1687–1761), Yanagisawa Kien (also called Ryū Rikyō, 1704–58), and Sakaki Hyakusen (1698–1752) were the best early eighteenth-century Japanese Nanga painters, but their work was obviously derived from Chinese sources. Two great artists of the following generation made truly creative, personal, and Japanese contributions to Nanga, establishing it as a significant school of painting in Japan. They were Ikeno Taiga (1723–76) and Yosa Buson (1716–83).

The flattening of pictorial space and tendency toward patternization in Taiga's landscapes are characteristic of Japanese painting compared to Chinese. The lively looseness of his brushwork and the light-hearted humor of his figures are unique. Taiga lived up to one of the ideals of Chinese literati artists more fully than most —he spent much of his life leisurely traveling around the country visiting friends, writing poetry, painting pictures, and climbing famous mountains.

Nanga artists were expected to be literary men, but their poems, like their paintings, were usually in Chinese style. Yosa Buson, however, was famous for his *haiku*—a uniquely Japanese form of poem.

Buson did not begin to paint Nanga seriously until about the age of forty, but he went on to develop a marvelously individual style characterized by feathery, impressionistic foliage, smokey mist, abbreviated compositions, cartoon-like figures, warm color harmonies, and a lyrical mood.

17 LANDSCAPES

Fūgai Honkō (1779–1847)

Pair of hanging scrolls.
Ink and light color on silk, each scroll 41½ x 14¼ inches.

Signed (center right of right scroll, upper left of left scroll):
Fūgai. Upper seal (rounded rectangular, intaglio):
undeciphered. Lower seal (rounded rectangular, intaglio):
Yū ("faint, profound, quiet").

Fūgai's traditional biography says almost nothing about him as a painter. He was a Zen priest associated primarily with the Kōja-kuin Temple in Mikawa Province (modern Aichi Prefecture). His surname was Heishi and his given name was Honkō. He was born in Ise Province (modern Mie Prefecture). As a child he did not get along well with others and sometimes spent whole days in village temples writing and painting.

In 1787, at the age of nine, Fūgai entered the priesthood at the Kōtaiji Temple in Ise Province. A few years later he did the usual tour of visitation, living and studying at various temples, finally becoming a disciple of the Zen master Genrō Okuryū at Kōshōji. Nothing further is recorded about him until 1818 when he was invited to live at the Entsūin in Osaka and restored this monastery to prominence.

Later Fūgai moved to the Kōjakuin Temple in Mikawa Province and it prospered under his guidance. He wrote a book on Zen with the enigmatic title of *One Hundred Rules for Playing Genryū's Iron Flute.*

Fūgai spent his old age living in a house he called the "Ushakurō" ("Crow-Magpie Mansion") in Osaka. He died on June 22, 1847, at the age of sixty-nine.

Another painter-priest, Fūgai Ekun (ca. 1568–1654), had the same art name written with the same two characters. He is often called Ana Fūgai ("Cave Fūgai") to distinguish him from Fūgai Honkō. Fūgai Ekun was an eccentric hermit monk who usually lived in a cave. His paintings are in a tradition completely different from those of Fūgai Honkō. While the latter was a Nanga artist, Fūgai Ekun painted Zenga.

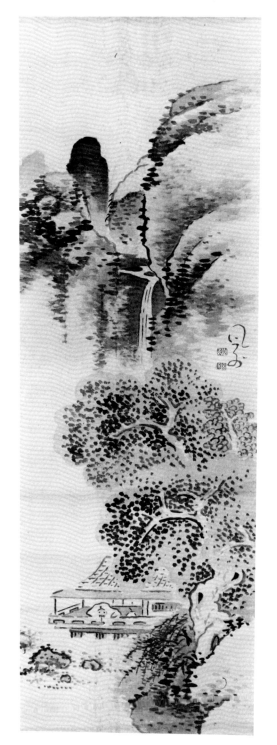

73

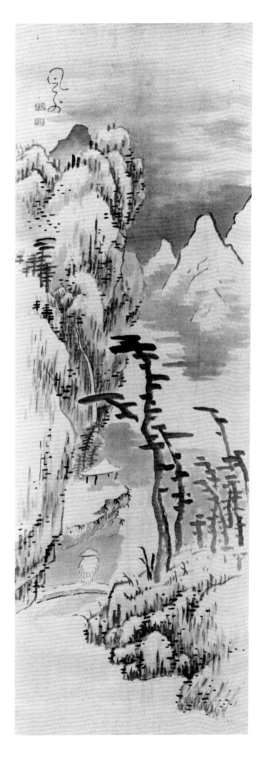

Zenga (Zen painting) was a tradition of abbreviated, enigmatic ink paintings by Zen priests of the Edo Period. The greatest artists of the school were Fūgai Ekun, Hakuin Ekaku (1685–1768), and Sengai Gibon (1751–1837). The subjects of Zenga were often figures from Zen or Taoist legends done in caricature-like style and accompanied by inscriptions. They had a serious didactic purpose: instruction in the principles of Zen Buddhism for the common people and student monks. Edo Period Zen Buddhism was far different from the more elitist Zen Buddhism of the Muromachi Period, which had served the monks and the warrior aristocracy. In the Edo Period priests like Hakuin and Sengai gave both spiritual and practical help to the common people.

The present summer and winter landscapes are pure Nanga. Like almost all of Fūgai Honkō's landscapes, the style derives from Ikeno Taiga. Fūgai was clearly a follower of Taiga, even though nothing in his biography or Taiga's documents their relationship.

The pointillist dots of foliage in the tree of the summer landscape are a direct "quotation" from Taiga, a stylistic mannerism he developed partly from the study of imported Chinese painting manuals, where the subtler brushwork of the original paintings was reduced to a pattern of dots on the woodblocks used for printing.

The loosely drawn, amusing little figure of the scholar in the lakeside pavilion is a Taiga figure type, though treated in an even more playful way by Fūgai. The "slithery" strokes representing the trunks of the foreground trees in the winter landscape are also borrowed from Taiga. Despite all the obvious borrowings, Fūgai's paintings are not mere copies. His compositions are a little more cursory and his treatment of space a little more arbitrary than Taiga's. His paintings have a different flavor: freer, briefer, and more eccentric, in keeping with Zen taste.

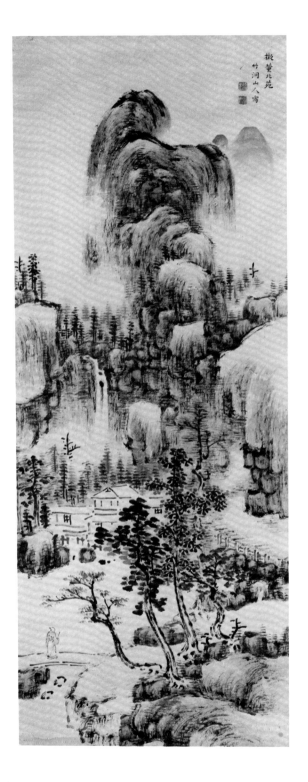

18 LANDSCAPE

Nakabayashi Chikutō (1776–1853)

Hanging scroll.
Ink on paper, 52¾ x 20¾ inches.

Signed (upper right): Chikutō Sanjin Sha (Painted by Mountain Man Chikutō) Gi Tō Hoku-en (In Imitation of Tung Pei-yuan, i.e.: Tung Yuan). Upper seal (square, intaglio): Seishō Sei In (True Seal of Seishō; Seishō was Chikutō's given name). Lower seal (square, intaglio): Azana Hakumei (art-name Hakumei).

Nakabayashi Chikutō and his friend Yamamoto Baiitsu (1783–1856) were the leading Nanga painters in the city of Nagoya. Chikutō's father was a physician but his obstetrics practice was not financially successful so the boy was brought up by an aunt. When he was fourteen Chikutō became the painting pupil of Yamada Kyujo (1747–93), a Nagoya artist who had studied under Sō Shiseki (see cat. no. 16). The following year Chikutō became the protégé of Kamiya Tenyū, a wealthy Nagoya merchant who had a large collection of Chinese paintings. Tenyū was also Baiitsu's sponsor and, through their mutual patron, the two artists became close friends. According to tradition, the art names by which we know the painters were bestowed on them by Tenyū at a Buddhist temple where they were admiring Chinese paintings of bamboo and plum blossoms. Chikutō means "Bamboo Cave" and Baiitsu means "Plum Blossom Leisure."

In 1801 Chikutō published the first of several books on painting theory. He believed that all artists should be judged in comparison to the great literati painters of China; he condemned the academic-professional approach of the Kanō School and the realistic intent of the Maruyama School. Following the death of their patron in 1802, Chikutō and Baiitsu moved to Kyoto. They eventually returned to Nagoya, but Chikutō moved to Kyoto permanently in 1815. He became a close friend of Rai Sanyō (1780–1832), the greatest Confucian scholar of the period.

Chikutō's inscription on the present *Landscape* says he painted it in imitation of Tung Yuan, one of the founders of the "Southern

School" in the Five Dynasties Period. Chikutō could only have known Tung Yuan's work through later copies and illustrations in the painting manuals.

The rounded, multi-layered peaks rising almost to the upper edge in the middle distance of this *Landscape* and the repeated horizontal dots suggesting foliage and texture are reminiscent of *Pavilions on the Mountains of the Immortals,* a large hanging scroll in the National Palace Museum, Taiwan, formerly attributed to Tung Yuan. The compositional scheme of it is also similar to the Palace Museum scroll, but without its richness of detail and its enveloping mists. There is something rather dry and conservative about Chikutō's painting; it is clearly the work of a man concerned with the correct presentation of orthodox Nanga doctrine. Nevertheless, Chikutō's art deserves its fame. His landscapes possess sound structure and rich visual texture achieved through the repetition of a great variety of dots, dabs, and linear strokes of ink or color wash.

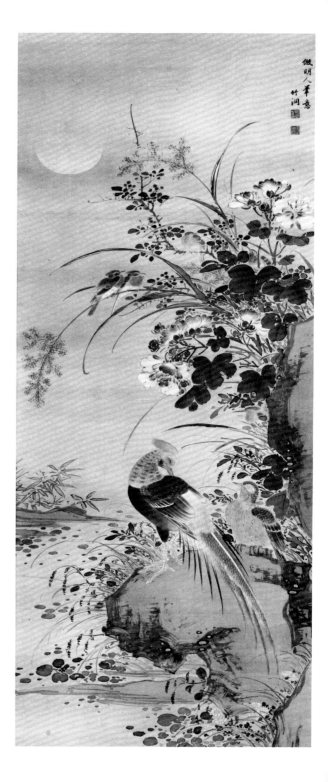

19 BIRDS AND FLOWERS IN THE MOONLIGHT

Nakabayashi Chikutō (1776–1853)

Hanging scroll.
Ink and color on silk, 50 x 21½ inches.

Signed (upper right): Chikutō, Hō Minjin Hitsui (Chikutō, Based on the Painting Style of a Ming Artist). Upper seal (square, intaglio): Seishō Sei In (True Seal of Seishō; Seishō was Chikutō's given name). Lower seal (square, intaglio): Azana Hakumei (art-name Hakumei).

Chikutō's teacher had studied under an artist of the Nagasaki School, which specialized in bird-and-flower subjects, and Chikutō was famous for bird-and-flower painting as well as landscapes. It is ironic that Chikutō, a champion of orthodox "Southern School" painting, also worked in the Nagasaki School style, whose realism, bright colors, and hard edges are part of the professional-academic "Northern School" tradition. Both styles had been introduced more or less simultaneously at Nagasaki, and the Japanese did not recognize the fundamental distinction between them.

The flattening of space and the decorative intent seen in this painting and in the work of Shen Nan-p'in have precedents in Ming Dynasty professional bird-and-flower painting. Chikutō's inscription says he based this painting on the style of "a man of Ming."

The only concession to Nanga in this painting is the "boneless" painting (no outlines) of many of the leaves and petals, although the rush and bamboo-grass leaves still have strong outlines.

In the present painting a pair of Chinese pheasants and some plump wagtails are surrounded by an almost vulgar profusion of flowers arranged in a flat, decorative way characteristic of Japanese painting. The effect of misty moonlight is superbly conveyed.

The Realistic School

This school of middle and late Edo Period painting is called *shaseiga* ("pictures sketched from nature"). Although artists of other schools sometimes sketched birds, animals, insects, or plants from life, and Realistic School artists did their finished paintings in the studio, the word *shaseiga* does convey the realistic intent that distinguishes this school. Dutch paintings and engravings were one of its sources. In Japan, as in Holland, merchants responded enthusiastically to realism.

The Realistic School was founded by Maruyama Ōkyo (1733–95), a farmer's son. Ōkyo developed a style of painting that was straightforward and easy to understand. Except for a few experiments early in his career, he left the mediums of European painting to the Yōga School and avoided European subject matter (*namban-e*, "southern barbarian painting"). He employed the traditional Japanese techniques he learned from his first teacher, a minor Kyoto Kanō painter named Ishida Yūtei (died 1785). Ōkyo's subjects were generally taken from the standard Japanese repertoire. But he presented them explicitly and with a tangible solidity that caught the fancy of the novelty-loving public. So successful was Ōkyo's art that the Shogun and the Emperor became his patrons. His subtle inclusion of Western-style perspective and modeling in light and shade learned from Dutch engravings fascinated his contemporaries. The colorful, realistic bird-and-flower paintings of Shen Nan-p'in were also a major factor in the development of Ōkyo's style.

20 BEAUTY UNDER CHERRY BLOSSOMS

Komai Genki (1747–97)

Hanging scroll.
Ink and color on silk, 36¼ x 12¼ inches.

Signed (lower right): Genki Sha (Painted by Genki). Seal (vertical rectangular, relief): Genki.

Published: Narazaki Muneshige (ed.), *Zaigai Hihō: Nikuhitsu Ukiyo-e* [Japanese paintings in Western collections: Floating World paintings] (Tokyo, 1969), p. 86.

Maruyama Ōkyo's two best pupils were Komai Genki and Nagasawa Rosetsu. Genki faithfully served his teacher throughout his career, as expected of a disciple, but Rosetsu struck out on his own as an independent painter after a brief period. This difference in temperament is apparent in the paintings of the two artists. Genki's art is calm, conservative, and classical; Rosetsu's is restless, bold, and inventive. Rosetsu's brush line is charged with energy; Genki's is quiet, dignified, and a little dull by comparison. Rosetsu was by far the more interesting painter of the two. Though Rosetsu is now gaining some reputation, neither artist has received the attention he deserves in the West.

Komai Genki was a native of Kyoto. The Japanese regard the classic restraint of his work as a reflection of his background in the ancient Imperial capital. He developed a reputation for *bijin-e* ("paintings of beautiful women"). In Edo and Osaka the young women depicted in *bijin-e* tended to be celebrated courtesans. In culturally elite Kyoto they were just as likely to be geisha or even *tōbijin* ("Chinese beauties"). The lovely young woman in Genki's scroll falls in another category. She is wearing a Japanese kimono and hair style. Her *obi* ("waist sash") is tied in back (courtesans' *obi* were tied in front). The style of her kimono and its lack of a house crest mean she is not a geisha. She is probably the daughter of a wealthy Kyoto merchant.

The painting style in Genki's *bijin-e* is entirely different from the Ukiyo-e style derived from Kanō and Yamato-e. Ōkyo developed the style himself, partly from the Chinese tradition of paintings of beautiful women founded by Ch'iu Ying (ca. 1510–51), known in Japan through late Ming Dynasty woodblock prints. This Ōkyo-Genki style is most apparent in the lines defining the folds of the robe in Genki's scroll. These smooth, calm lines of even thickness are entirely different from the barbs, angles, and violent modulations of Kanō line and its derivatives.

The line drawing, the coloring, and the placement of the figure and tree on the undifferentiated background of *Beauty under Cherry Blossoms* are completely within the Chinese-Japanese tradition. However, there is a hint of Western-style realism: the trunk and branches of the cherry tree are done in graded wash without lines but with the darker transverse strokes for bark texture carefully curved to suggest three-dimensional volume.

The Japanese use flowers to allude to the changing seasons. This may be seen in Genki's painting. The spring cherry blossoms on the tree are balanced by the autumn grasses, bush clover, and flying geese on the girl's kimono.

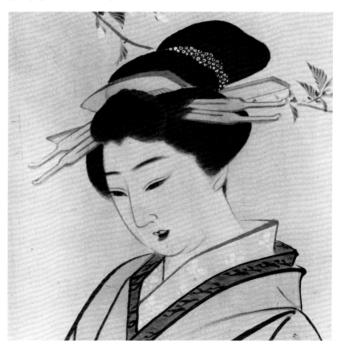

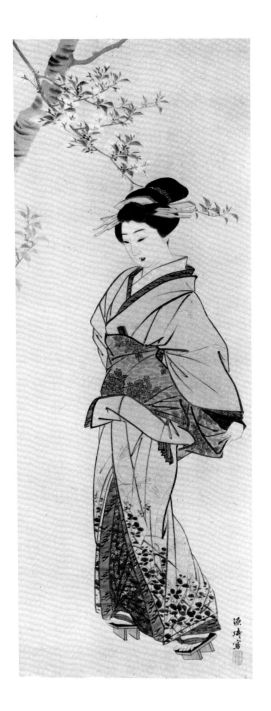

21 PUPPIES AND BAMBOO IN MOONLIGHT

Nagasawa Rosetsu (1754–99)

Set of four *fusuma* hinged together as a pair of two-panel screens.
Ink and light color on paper, each screen 69 x 76 inches.

Signed (upper right of right panel): Rosetsu Sha I (Conceived and painted by Rosetsu). Seal (irregular round, relief): Gyo ("Fish," one of Rosetsu's art names).

Published: Nakamura Tanio, *Kobijutsu* [Old art] No. 18 (Tokyo, 1967). Robert Moes, *Rosetsu: Exhibition of Paintings by Nagasawa Rosetsu, Denver Art Museum* (Denver, 1973), p. 142.

Nagasawa Rosetsu does not fit comfortably in the Realistic School. His style was too personal. Its expressiveness and inventiveness went far beyond the classic restraint and solid form of Ōkyo and his followers. According to tradition, he was expelled from Ōkyo's studio for insolent behavior. He is supposed to have handed Ōkyo a sketch for comment and correction. After the drawing received withering criticism from Ōkyo, Rosetsu exposed it as the master's own work. Although the story may be fictional, it reflects the same sort of playful humor we find in many of Rosetsu's paintings. *Puppies and Bamboo in Moonlight* is no exception. This style of puppy painting was developed by Ōkyo; his pups are a little more tangible, but Rosetsu's have livelier personalities.

Rosetsu was the son of a low-ranking samurai in Tamba Province. He was befriended by the Yokoyama, a wealthy merchant family in Yodomachi. They helped him to go to Kyoto for further study, and he became a pupil of Maruyama Ōkyo. His early work is similar in style to his teacher's. By 1787, however, when he painted the splendid cycles of *fusuma* paintings at three Zen temples in Nanki (Wakayama Prefecture), Rosetsu was in full command of his own style. When at his best, he has far more power, vigor, and wit than Ōkyo.

The 1787 Nanki *fusuma* bear the same huge seal with tortoise-shaped contour as *Puppies and Bamboo in Moonlight*. The art name Gyo ("Fish") represented by the single character in this seal is said

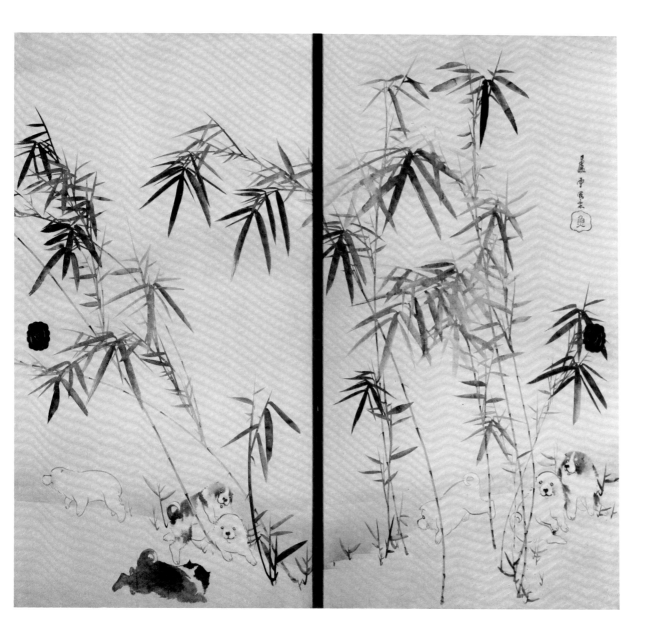

to refer to a dream Rosetsu once had about a fish frozen in the ice of a winter stream. After sunshine melted the ice, it swam happily away. Rosetsu interpreted this to mean he should leave Ōkyo's studio and work on his own.

Sometime between May 1792 and the winter of 1794, a large section of the bordering line at the upper right of the big wooden "Gyo" seal broke away. Its impression on the present *fusuma* is intact, so they were painted prior to that date. The style of their signature suggests a date slightly later than that of the 1787 Nanki paintings, though some of the latter depict almost identical puppies.

The area representing the ground on which the puppies play is suggested by bare white paper, a convention normally used for snow scenes in Chinese or Japanese landscape painting. Here it indicates ground bathed in moonlight. The disc of the moon is shown enclosed by a zone of dilute gray wash behind the upper stalk of bamboo in the third panel from the right.

Bamboo painting in ink provided an appropriate vehicle for calligraphic brush strokes and became a standard painting type in China. Bamboo symbolized the scholarly gentleman who bends under adversity but never breaks. Japanese bamboo painting is never quite as good as Chinese bamboo painting, but Rosetsu's is splendid. Instead of following the canons for bamboo painting, he developed his own type by observing the characteristics of an actual species. He has captured its growth, its articulation, and its movement in the wind with great success.

22 MONKEYS

Mori Sosen (1747–1821)

Single-panel screen.
Ink and color on paper, 56½ x 46½ inches.

Signed (lower right): Reimei Sanjin Sha (Painted by the Mountain Man Reimei, Bright Spirit, one of Sosen's art names). Upper seal (square, intaglio): Rei (Spirit). Lower seal (square, intaglio): Sosen In (Seal of Sosen).

Mori Sosen, though not a pupil of Ōkyo, was profoundly influenced by his realism, particularly in animal paintings. Sosen was extremely successful; Ōkyo admired Sosen's paintings of monkeys. The demand for his paintings of monkeys was so great that vast quantities of forgeries of his work were produced, even during his lifetime. Throughout his long career, however, Sosen never rose above the level of a technically competent artisan. His paintings have none of the wit and verve found in Rosetsu's work.

Sosen came from either Nishinomiya or Nagasaki and lived in the sprawling mercantile city of Osaka. He began his painting career as the student of a minor Kanō artist named Yamamoto Jushunsai. Sosen developed a highly realistic style of monkey painting, abandoning the Chinese gibbon, which had often appeared in Zen art, in favor of the single monkey species native to the Japanese islands. Sosen kept Japanese monkeys in pens behind his house so he could sketch them from life. When a critic complained that a monkey in one of his paintings looked tame, Sosen went to the mountains and studied monkeys in their natural habitat for even greater realism.

Sosen used a special painting technique developed by Ōkyo for the rendering of fur. *Kegaki*, the painting of countless short, thin lines over an area of light brown wash, suggests the texture of soft fur. So famous did his monkey paintings become that he came to be called "Monkey Sosen" by his contemporaries. Other subjects eluded his rather meager talents, as the feeble landscape settings of his animal pictures suggest. Few figure paintings or independent landscapes by Sosen have survived. They are said to have received very adverse criticism when he painted them.

23 PEACOCK

Mori Sosen (1747–1821)

Single-panel screen.
Color and gold leaf on paper, 56½ x 46½ inches.

Signed (lower right): Sosen Hitsu (Painted by Sosen). Upper seal (oval, relief): Shushō (Sosen's given name). Lower seal (square, intaglio): Sosen In (Seal of Sosen).

This painting originally formed the other side of the single-panel screen (*tsuitate*) of *Monkeys* (cat. no. 22). This type of screen stood on the front edge of the veranda in the entrance hall of a Japanese mansion.

This style of brightly colored, tight, realistic peacock painting was a specialty of Maruyama Ōkyo. Sosen's version follows Ōkyo's formula to the last pinfeather. Minute concentration on the exact appearance of surface detail was inevitably done at the expense of movement, articulation, and life. This peacock is not a living bird. John James Audubon got similar results by shooting birds and sketching their remains.

Sosen painted *Peacock* and *Monkeys* prior to 1806. That year, at the age of sixty, he changed the ideogram "So" in his art name from one meaning "ancestor" to another of the same pronunciation meaning "to aim at."

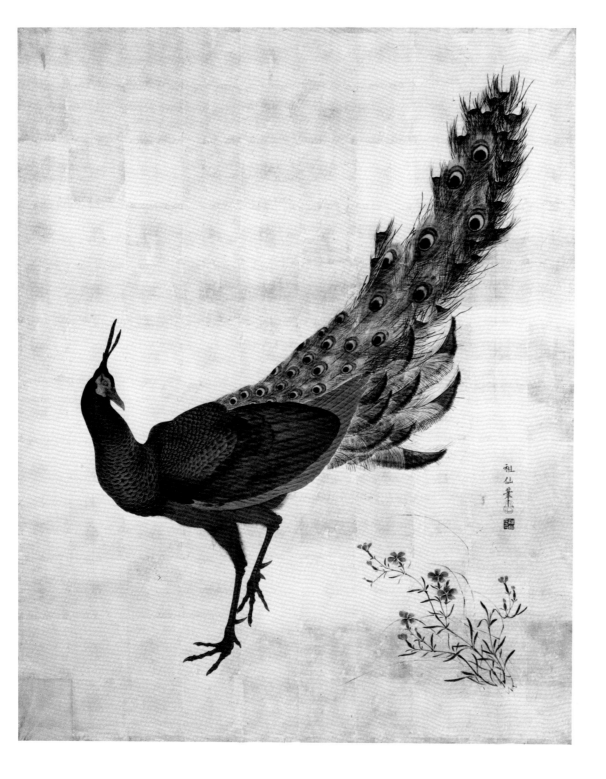

24 DEER

Mori Sosen (1747–1821)

Hanging scroll.
Ink and color on silk, 38¾ x 14¼ inches.

Signed (lower right): Sosen. Seal (square, intaglio): Reibyō Sei-in (True Seal of Reibyō, "Cat Spirit," one of Sosen's art names).

Sosen was much more successful with this pair of deer than with *Peacock* (cat. no. 23). Deer were his second specialty; he painted birds only rarely. His *kegaki* technique is at its best here, conveying the texture of warm, soft fur without disrupting the animals' form, movement, or vitality. Each of the deer has an individual personality—the slightly indignant and suspicious glance of the buck contrasts with the more introspective and innocent expression of the doe. The antlers are modeled in light and shade for an illusion of three-dimensional volume unknown in Japan before the advent of Ōkyo's Realistic School. Sosen's only failure in this scroll is his placement of the animals on the ground plane; they do not stand directly on the ground but seem to float just above it. Sosen had similar difficulty in most of his other surviving works.

Deer was painted prior to 1806; the "So" in the signature is the ideogram meaning "ancestor." The poem, written by "Raizan," reads:

Wakakusa no tsumamo	My darling wife
Waga mo to	Beside me also.
Kasugano no	In Kasuga meadow's
Kasumi ni	Mists
Komoru	Veiled,
Haru no Saoshika	A young spring stag.

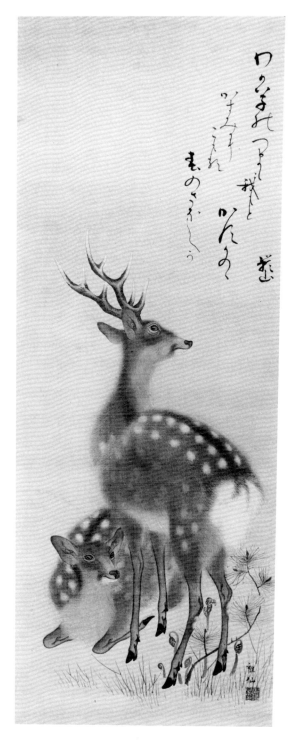

The Shijō School

Ōkyo's most famous pupil, Matsumura Goshun (1752–1811), left the Realistic School to found his own painting tradition, the Shijō School, named after Shijō ("Fourth Avenue") in Kyoto, where his studio was located. Early in his career Goshun studied *haiku* poetry and Nanga painting under Yosa Buson. After Buson's death, he became a pupil of Maruyama Ōkyo, whose realistic approach was the antithesis of Nanga.

Goshun led a varied and colorful existence. He had a lifelong reputation as a prodigious drinker. At one time, he supported himself by writing the mandatory love letters sent to patrons of the courtesans of one of Kyoto's famous licensed quarters. At the age of thirty he became a Buddhist monk, though he continued to lead a secular life. After training in Ōkyo's atelier, Goshun opened his own painting studio and became prominent enough to receive commissions from the Imperial court.

The Shijō style created by Goshun combines something of the informal, soft, repetitive brushwork of Nanga with the exactitude of the Realistic School. Goshun trained a virtual army of pupils, but none were as gifted as their teacher. Their work is usually excessively sentimental, but it found a ready market, and the school prospered for several generations.

25 BIRDS AND FLOWERS

Matsumura Keibun (1779–1843)

Pair of two-fold tea ceremony screens.
Ink, light color, and gold fleck on silk, each screen 28 x 74 inches.

Signed (lower right of right screen, lower left of left screen): Kakei (Keibun's art name). Upper seal (square, intaglio): Undeciphered, Sei-in (True Seal of Undeciphered). Lower seal (square, intaglio): Kakei.

Matsumura Keibun, Matsumura Goshun, and Okamoto Toyohiko (1773–1845) are ranked as the three greatest artists of the Shijō School. Keibun was especially noted for bird-and-flower paintings, and these little screens are typical of his work. The convincing naturalism, based on sketching from nature, derives from Ōkyo's style as transmitted by Goshun, Keibun's older brother and teacher. The classic restraint and impeccable placement speak of Keibun's upbringing as a man of culture in the old Imperial court city of Kyoto, as well as his study of Ming and Ch'ing art theory under the Confucian scholar Koishi Genzui. The dove in the flowering plum tree reminds one of paintings by the last Northern Sung Emperor, Hui-tsung, much more than it does of Shen Nan-p'in's work. Paintings attributed to Hui-tsung were owned by some of the Kyoto Zen temples and must have been studied by Keibun.

In the left-hand screen is a descriptive detail recording a momentary effect, something foreign to the timeless perfection of a Sung bird-and-flower painting or the slick works of Shen Nan-p'in. Only in the realistic art of the Maruyama-Shijō School or in the paintings of Keibun himself could we expect to see it. Mottled, bare silk peeking through the background wash suggests the falling snow flicked from the springy branch by the departure of the bush warbler. The pair of birds sharing the plum tree with the dove in the companion screen are Manchurian tits.

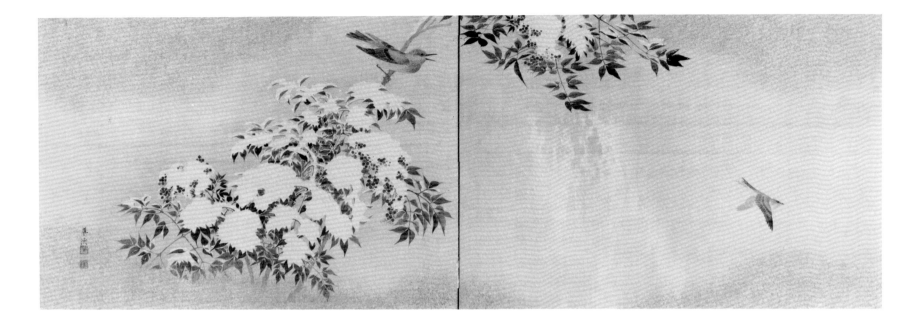

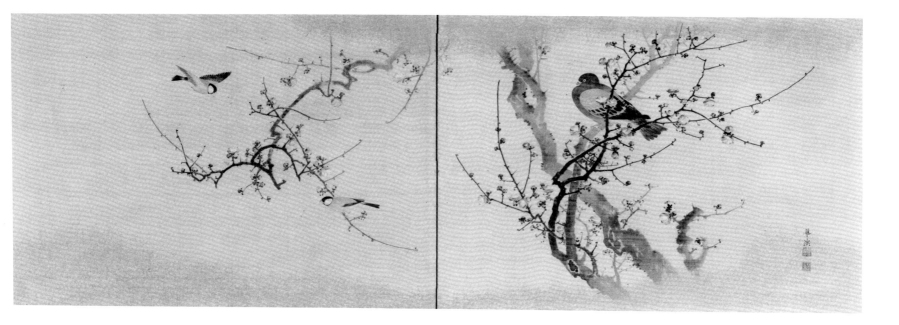

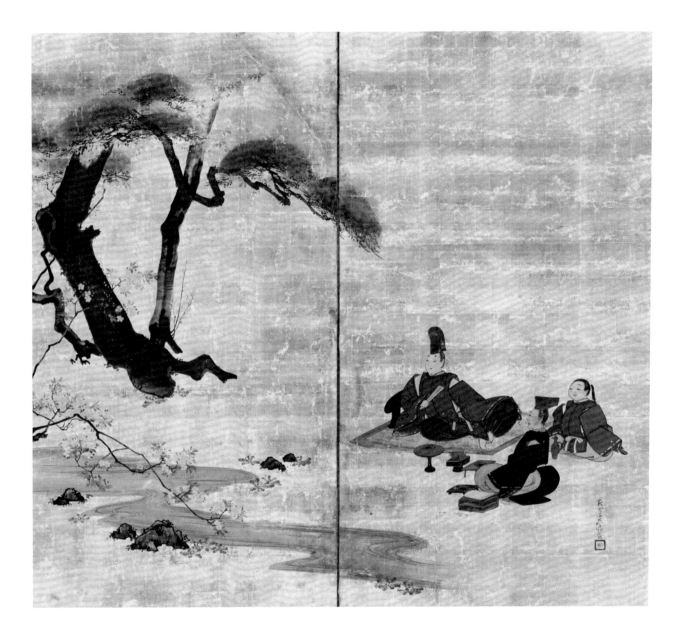

Dissatisfaction with Tokugawa rule had been common throughout the Edo Period. Because of the tight control the regime maintained over every aspect of Japanese life, it managed to survive until the middle of the nineteenth century, when it was finally overthrown by a group of feudal lords calling themselves loyalists because of their plan to restore ruling power to the Emperor.

Commodore Matthew Perry arrived in Japan with a flotilla of warships in 1853. He delivered a letter to Shogun Tokugawa Ieyoshi from Millard Fillmore requesting that Japanese ports be opened to foreign ships for water and supplies. He returned for the Shogun's answer the following year. After a month-long meeting with Japanese officials, a provisional treaty was signed opening two ports to American ships.

The loyalists took advantage of Perry's visits. They pointed out—quite correctly—that the Shogunate had left Japan at the mercy of foreign barbarians by failing to build coastal defences and introduce modern weaponry.

After much intrigue and considerable bloodshed, Emperor Meiji took office in 1868 under a Western-style constitution and parliament. The Imperial court was moved from Kyoto to Edo, renamed Tokyo ("Eastern Capital") to mark the change. Japan subsequently Westernized and industrialized with remarkable speed.

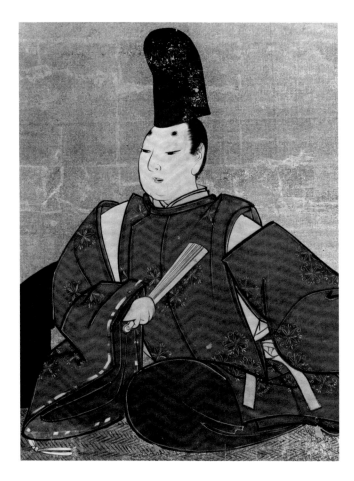

26 NARIHIRA VIEWING CHERRY BLOSSOMS

Shibata Zeshin (1807–91)

Two-fold screen.
Color, lacquer, and gold leaf on silk, 69 x 75 inches.

Signed (lower right): Tairyūkyo Zeshin Sei (Made by Tairyūkyo Zeshin; Tairyūkyo is one of Zeshin's art names).
Seal (square, relief): Furumitsu (one of Zeshin's art names).

Published: Gō Tadatomi (ed.), "Shibata Zeshin," *Nihon no Bijutsu* [Japanese art] no. 93 (Tokyo, 1974), fig. 80.

Shibata Zeshin was the greatest lacquer craftsman of the nineteenth century. A sort of Renaissance man, Zeshin was also a

superb painter, tea master, and *haiku* poet, although he always modestly referred to himself as a lacquerer.

Zeshin was born in Edo, where his father had a tobacco business. At the age of eleven he began his apprenticeship as a lacquer craftsman under Furumitsu Kanga. Zeshin uses Furumitsu as his own art name in the seal on this screen. When he was sixteen Zeshin began the study of painting with Suzuki Nanrei (1775–1844), a student of Watanabe Nangaku (1763–1813), one of Maruyama Ōkyo's best pupils. At Nanrei's recommendation Zeshin went to Kyoto and studied under the Shijō School artist Okamoto Toyohiko for two years. Zeshin is therefore regarded as a Shijō School painter, even though his creative talent and interest in lacquer art completely transcended the limitations of the style. It was during his stay in Kyoto that Zeshin began his serious study of *haiku* and tea ceremony.

Zeshin achieved fame as a lacquer craftsman and painter while still in his thirties. He lived in the Asakusa section of Tokyo, where he spent a long and productive career painting and lacquering. He invented several new lacquer techniques and re-invented old ones that had been lost. He found a way to make lacquer flexible enough for scroll paintings. He often incorporated it in his paintings, taking advantage of its translucence and luster.

The present screen is a superb example of Zeshin's technical brilliance and stylistic eclecticism. The figure in the tall court cap is Narihira, hero of the *Ise Monogatari* (see cat. no. 12). He and his companion and their attendant are painted in the old Kamakura Period Yamato-e style as transmitted by the Tosa School in the Muromachi Period and the Sumiyoshi School, which had been created to serve as the "Japanese style" school of the Tokugawa Shoguns.

The Sōtatsu-like "dancing" pine tree, the Kōrinesque serpentine brook, the decorative placement of the flat forms, and the brilliant colors reflect Rimpa, with its craft traditions, much more than Shijō. Most of Zeshin's paintings show such an affinity. It is only by the convention of his artistic lineage that he is called a Shijō painter.

Discussion of Zeshin's sources says nothing about the consummate excellence of this painting. In addition to his brilliant talent as a designer, draftsman, and colorist, Zeshin managed to infuse life into his figures, his trees, and his flowers. He conveys a sense of mood through the perfect nuance of gesture. Narihira leans lanquidly on his armrest, but his poised fan, erect head, and intense gaze reveal his sudden poetic inspiration on beholding the cherry blossoms.